Magic Lantern Guides

Canon

DIGITAL
EOS REBEL XTi
EOS 400D
DIGITAL

Michael Guncheon

LARK BOOKS
A Division of Sterling Publishing,Co., Inc.
New York

Editor: Kara Helmkamp
Book Design and Layout: Michael Robertson
Cover Design: Thom Gaines
Associate Art Director: Lance Wille

Library of Congress Cataloging-in-Publication Data

Guncheon, Michael A., 1959-
 Canon Eos Rebel XTI : Eos 400D / Michael Guncheon. -- 1st ed.
 p. cm. -- (Magic lantern guides)
 Includes index.
 ISBN-13: 978-1-60059-099-3 (pb-trade pbk. : alk. paper)
 ISBN-10: 1-60059-099-3 (pb-trade pbk. : alk. paper)
 1. Canon camera--Handbooks, manuals, etc. 2. Digital cameras--Handbooks,
manuals, etc. I. Title.
 TR263.C3G96 2006
 771.3'1--dc22

 2006101471

10 9 8 7 6 5 4 3 2 1
First Edition

Published by Lark Books, A Division of
Sterling Publishing Co., Inc.
387 Park Avenue South, New York, N.Y. 10016

© 2007, Michael Guncheon
Photography © Michael Guncheon unless otherwise specified

Distributed in Canada by Sterling Publishing,
c/o Canadian Manda Group, 165 Dufferin Street
Toronto, Ontario, Canada M6K 3H6

Distributed in the United Kingdom by GMC Distribution Services,
Castle Place, 166 High Street, Lewes, East Sussex, England BN7 1XU

Distributed in Australia by Capricorn Link (Australia) Pty Ltd.,
P.O. Box 704, Windsor, NSW 2756 Australia

If you have questions or comments about this book, please contact:
Lark Books
67 Broadway
Asheville, NC 28801
(828) 253-0467

Printed in United States

ISBN 13: 978-1-60059-099-3
ISBN 10: 1-60059-099-3

For information about custom editions, special sales, premium and corporate purchases, please con-
tact Sterling Special Sales Department at 800-805-5489 or specialsales@sterlingpub.com.

Michael Guncheon
Canon EOS DIGITAL Rebel XTi
Canon EOS 400D

Cannon b batteries
NB - 2LH

Contents

Digital Photography Takes the Next Step

When the original EOS Digital Rebel was introduced by Canon in 2003, it revolutionized the world of digital SLRs. For the first time, photographers could buy a digital SLR for under $1,000 US. In 2005 Canon introduced the EOS Digital Rebel XT, improving on almost every aspect of the original Digital Rebel. Now, with the third generation Canon EOS Digital Rebel XTi, also known as the EOS 400D outside North America, Canon has continued to set the standard for affordable digital SLRs.

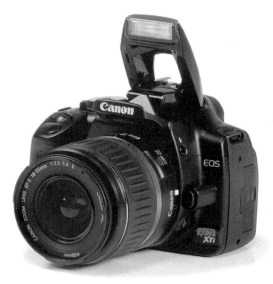

The Canon EOS Digital Rebel XTi offers a huge jump in sensor megapixels for its affordable price. It is completely customizable for the advanced photographer, and can also function completely automatically for beginning digital photographers.
Photo © Marianne Wallace

Introduced in September of 2006, the XTi's body measures only 4.98 x 3.71 x 2.56 inches (126.5 x 94.2 x 65 mm) and weighs just 18 ounces (510 g) without lens. Yet the Rebel XTi offers a newly developed 10.1 megapixel image sensor along with additional features that compare favorably with cameras that have a much higher price tag. It does far more than simply replace the Digital Rebel XT, improving on most features and including new technology like a self-cleaning sensor unit and Dust Delete Data detection.

Some photographers have purchased the Rebel XTi as an upgrade from the EOS Digital Rebel or Rebel XT. Others, however, are making their first high-quality digital camera investment. For those photographers new to digital SLR photography, this book begins with an assortment of basic topics and concepts. Experienced digital photographers (and anyone who has read guides to other Canon EOS digital SLRs) already familiar with these terms and concepts should skip ahead to the detailed sections on camera operation beginning on page 101.

As a matter of convenience (and easier reading), I will usually refer to the Canon EOS Digital Rebel XTi simply as the Rebel XTi. As mentioned, outside of North America the same camera is known as the Canon EOS 400D.

Canon created this multi-featured camera so that it would meet the requirements of photographers of all levels of experience. While this book thoroughly explores all of the Rebel XTi's features, you certainly don't need to know how to operate every one of them. Once you comprehend what a feature does, you may decide it is not necessary to master it in order to achieve your desired photographic results. Learn the basic controls. Explore any additional features that work for you. Forget the rest. At some point in the future you can always delve further into this book and work to develop your Rebel XTi techniques and skills. Just remember that the best time to learn about a feature is before you need it.

Digital cameras do some things differently than traditional film cameras, making them exciting and fun to use,

no matter whether you are an amateur or a pro. For digital beginners, many of these differences may seem complicated or confusing. Though most of the features found on a traditional Canon EOS camera are also available on the Rebel XTi, there are many new controls and operations unique to digital. Other features have been added to increase the camera's versatility for different shooting styles and requirements. The goal of this guide is to help you understand how the camera operates so that you can choose the techniques that work best for you and your style of photography.

Differences between Digital and Film Photography

Just a few years ago it was easy to tell the difference between photos taken with a digital camera and those shot with a traditional film camera: Pictures from digital cameras didn't measure up in quality. This is no longer true. With the Rebel XTi, you can make prints of at least 16 x 20 inches (40.6 x 50.8 cm) that will match an enlargement from 35mm film.

While there are differences between film and digital image capture, there are many similarities as well. A camera is basically a box that holds a lens that focuses the image. In traditional photography, the image is recorded on film and later developed with chemicals. In digital photography, however, the camera converts the light to an electronic image and it can do more to that image in terms of internal processing.

Film vs. the Sensor
Both film and digital cameras expose pictures using virtually identical methods. The light metering systems are based on the same technologies. The sensitivity standards for both film and sensors are similar, and the shutter and aperture mechanisms are basically the same. These similarities exist because both film and digital cameras share the same function: to deliver the amount of light required by the sensitized medium (film or image sensor) to create a picture you will like.

However, image sensors react differently to light than film does. From dark areas (such as navy blue blazers, asphalt, and shadows) to midtones (blue sky and green grass) to bright areas (such as white houses and snowy slopes), a digital sensor responds to the full range of light equally, or linearly. Film, however, responds linearly only to midtones (those blue skies and green fairways). Therefore, film blends tones very well in highlight areas, whereas digital sensors often cut out at the brightest tones. Digital typically responds to highlights in the way that slide film does, and to shadows as does print film.

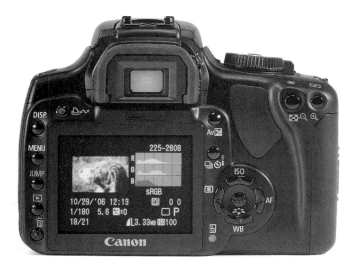

The Rebel XTi's large LCD monitor makes it easy to see your photographic results immediately.

The LCD Monitor

One of the major limitations of film is that you really don't know if your picture is a success until the film is developed. You have to wait to find out if the exposure was correct or if something happened to spoil the results (such as the blurring of a moving subject or stray reflections from flash). With a digital

SLR camera like the Rebel XTi, you can review your image on the LCD monitor (a screen usually found on the back of the camera) within seconds of taking the shot. Though you may not be able to see all the minute details on this small screen, the display provides a general idea of what has been recorded, so you can evaluate your pictures as soon as you have shot them.

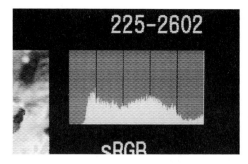

The histogram is a helpful tool for getting your exposure as correct as possible.

The Histogram

Whether you are shooting film or digital, the wrong exposure will cause problems. Digital cameras do not offer any magic that lets you beat the laws of physics: Too little light makes dark images; too much makes overly bright images. Fortunately, the LCD monitor gives an essentially instantaneous look at your exposure. While this small version of your image isn't perfect, it will give you a good idea of whether you are exposing properly or not.

With traditional film, many photographers regularly "bracket" exposures (shoot the same image several times while changing settings, e.g. increasing or decreasing shutter speed or aperture on consecutive shots) in order to ensure they get the exposure they want. You can still bracket with digital if you want—the XTi can do it automatically for you—but there is less of a need because you can check your exposure as you shoot. The Rebel XTi's histogram function will help in this evaluation. This feature, which is unique to digital photography, displays a graph that allows you to immediately determine the range of brightness levels within the image you have captured.

Memory cards make traveling with your Rebel XTi easy and convenient. They are extremely compact and can hold hundreds of images.

Film vs. Memory Cards

Memory cards are necessary to store images captured by a digital camera. These removable cards affect photographic technique by offering the following advantages over film:

More photos: Standard 35mm film comes in two sizes: 24 and 36 exposures. Memory cards come in a range of capacities, and all but the smallest are capable of holding more exposures than film (depending on the selected file type).

Reusable: Once you make an exposure with film, you have to develop and store the negative and print. Due to a chemical reaction, the emulsion layer is permanently changed, so the film cannot be reused. With a memory card, you can remove images at any time, opening space for additional photos. This simplifies the process of organizing your final

set of images. Once images are transferred to your computer (or other storage medium—burning a CD is recommended), the card can be reused.

Durability: Memory cards are much more durable than film. They can be removed from the camera at any time (as long as the camera is turned off) without the risk of ruined pictures. They can even be taken through the carry-on inspection machines at the airport without suffering damage.

No ISO limitations: Digital cameras can be set to record at different light sensitivities or ISO speeds. This can be done at any time, meaning the card is able to capture images using different ISO settings, even on a picture-by-picture basis. With film, you have to expose the entire roll before you can change sensitivity.

Small size: In the space taken up by just a couple rolls of film, you can store or carry multiple memory cards that will hold hundreds of images.

Greater image permanence: The latent image on exposed, but undeveloped, film is susceptible to degradation due to conditions such as heat and humidity. With new security precautions at airports, the potential for film damage has increased. But digital photography allows greater peace of mind. Not only are memory cards durable, their images can also be easily downloaded to storage devices or laptops. But with this flexibility comes the chance that images can be erased—so make sure you make backups.

ISO

ISO is an international standard method for quantifying film's sensitivity to light. Once an ISO number is assigned to a film, you can count on its having a standard sensitivity, or speed, regardless of the manufacturer. Low numbers, such as 50 or 100, represent a relatively low sensitivity, and films with these speeds are called slow films. Films with high numbers, such as 400 or above, are more sensitive and referred to as fast. ISO numbers are mathematically proportional to the

sensitivity to light. As you double or halve the ISO number, you double or halve the film's sensitivity to light (i.e. 800 speed film is twice as sensitive to light as 400 speed, and it is half as sensitive to light as 1600 speed).

Technically, digital cameras do not have a true ISO. The sensor has a specific sensitivity to light. Its associated circuits change its relative "sensitivity" by amplifying the signal from the chip. For practical purposes, however, the ISO setting on a digital camera corresponds to film. If you set a digital camera to ISO 400, you can expect a response to light that is similar to ISO 400 film.

Unlike film, changing ISO picture-by-picture is easy with a digital camera. By merely changing the ISO setting, you use the sensor's electronics to change its "sensitivity". It's like changing film at the touch of a button. This capability provides many advantages. For example, you could be indoors using an ISO setting of 800 so you don't need flash, and then you can follow your subject outside into the blazing sun and change to ISO 100. The Rebel XTi camera offers an extremely wide range of ISO settings from 100 to 1600.

Noise and Grain

Noise in digital photography is the equivalent of grain in film photography. It appears as an irregular, sand-like texture that, if large, can be unsightly and, if small, is essentially invisible. (As with grain, this fine-patterned look is sometimes desirable for certain creative effects.) In film, grain occurs due to the chemical structure of the light-sensitive materials. In digital cameras, noise occurs for several reasons: sensor noise (caused by various things, including heat from the electronics and optics), digital artifacts (when digital technology cannot deal with fine tonalities such as sky gradations), and JPEG artifacts (caused by image compression). Of all of these, sensor noise is the most common.

In both film and digital photography, grain or noise will emerge when using high ISO speeds. And, on any camera, noise will be more obvious with underexposure. With digital

cameras, noise may also be increased with long exposures in low-light conditions. With the Rebel XTi, Canon has developed second generation, on-chip, noise-reduction circuitry. This technology gives the camera incredible image quality—at high ISOs with low noise—that simply wasn't possible in the past. This camera also has a number of new technologies that create better images with long exposures.

File Formats

A digital camera converts the continuous (or analog) image information from the sensor into digital data. The data may be saved into one of several different digital file formats, including RAW and JPEG.

One very useful feature of digital SLRs is their ability to capture a RAW file. RAW files are image files that include information about how the image was shot but have little processing applied by the camera. They also contain 12-bit color information, which is the maximum amount of data available from the sensor. (It is a little confusing that the RAW file format is actually a 16-bit file, though the data from the sensor is 12-bit.) The Rebel XTi uses the same advanced RAW format developed for the Canon EOS-1D Mark II, the CR2 file, which includes more metadata (data about the image) than before.

JPEG (Joint Photographic Experts Group) is a standard format for image compression and is the most common file created by digital cameras. Digital cameras use this format because it reduces the size of the file, allowing more pictures to fit on a memory card. It is highly optimized for photographic images.

Both RAW and JPEG files can produce excellent results. The unprocessed data of a RAW file can be helpful when faced with tough exposure situations, but the small size of the JPEG file is faster and easier to deal with. It is important to consider that a JPEG image might look great right out of the camera, while a RAW file may need quite a bit of adjustment before the image looks good.

Digital Resolution

When we talk about resolution in film, we are simply referring to the detail that the film can see or distinguish. Similarly, when referring to resolution in the context of lenses, we are measuring the lens' ability to separate elements of detail in a subject. Unfortunately, resolution is not as simple a concept when it comes to digital photography.

Resolution in the digital world is expressed in different ways, depending on what part of the digital loop you are working in. For example, resolution for digital cameras indicates the number of individual pixels that are contained on the imaging sensor. This is usually expressed in megapixels. Each pixel captures a portion of the total light falling on the sensor. And it is from these pixels that the image is created. Thus, an 8-megapixel camera has 8 million pixels covering the sensor.

On the other hand, when it comes to ink jet printing, the usual rating of resolution is in dots-per-inch (dpi), which describes how many individual dots of ink exist per inch of paper area, a very different concept. Although it may be confusing, it is important to remember that a digital image's resolution is completely different than a printer's resolution.

Dealing with Resolution: The Rebel XTi offers three different resolution settings from 2.5 to 10.1 megapixels. Although you don't always have to choose the camera's maximum resolution, generally it is best to use the highest setting available (i.e., get the most detail possible with your camera). You can always reduce resolution in the computer, but you cannot recreate detail if you never captured the data to begin with. Keep in mind that you paid for the megapixels in your camera! The lower the resolution with which you choose to shoot, the less detail your picture will have. This is

The Rebel XTi's 10.1 megapixel sensor captures great detail at ⇨ *almost any setting. If you plan to make large prints of your images, shoot at the highest image resolution.*

particularly noticeable when making enlargements. The Rebel XTi has the potential of making great prints at 16 x 20 inches (40.6 x 50.8 cm) and larger, but only when the image is shot at 10.1 megapixels.

Digital camera files generally enlarge very well in programs like Adobe Photoshop Elements, especially if you recorded them in RAW format first. (Recall that there is more data with which to work in the RAW format.) The higher the original shooting resolution, the larger the print you can make. However, if the photos are specifically for email or webpage use, you do not need to shoot with a high resolution in order for the images to look good on screen.

Remember, you can always reduce the resolution later in the computer. But you can't increase resolution without producing digital artifacts.

The Color of Light
Anyone who has shot color slide film in a variety of lighting conditions has horror stories about the resulting color from those conditions. Color reproduction is affected by how a film is "balanced" or matched to the color of the light. Our eyes adapt to the differences, but film does not.

In practical terms, if you shoot a daylight-balanced (outdoor) film while indoors under incandescent lights, your image will have an orange cast to it. For accurate color reproduction in this instance, you would need to change the film or use a color correction filter. One of the toughest popular lights to balance is fluorescent. The type and age of the bulbs will affect their color and how that color appears on film, usually requiring careful filtration. Though filters are helpful in altering and correcting the color of light, they also darken the viewfinder, increase the exposure, and make it harder to focus and compose the image.

With digital cameras, all of this changed. A digital camera acts more like our eyes and creates images with fewer color problems. This is because color correction is managed by

the white balance function, an internal setting built into all digital cameras that allows them to use electronic circuits to neutralize whites and other neutral colors without using filters. This technology can automatically check the light and calculate the proper setting for the light's color temperature. White balance can also be set to specific light conditions, or custom-set for any number of possible conditions. Thanks to this technology, filters are rarely a necessity for color correction, making color casts and light loss a non-issue.

Cost of Shooting

While film cameras have traditionally cost less than digital cameras, an interesting phenomenon is taking place that makes a digital camera a better overall value. Memory cards have become quite affordable. Once a card is purchased, it can be used again and again. Therefore, the cost per image decreases as the use of the card increases. Conversely, the more pictures you take with film, the more rolls you have to buy (and process), and the more expensive the photography becomes.

With digital cameras there is virtually no cost to shooting a large number of photos. The camera and memory card are already paid for, whether one, ten, or a hundred images are shot. This can be liberating because photographers can now try new ways of shooting, experiment with creative angles never attempted before, and so much more.

Features and Functions

In an effort to appeal to a broad spectrum of buyers, camera manufacturers equip today's cameras with many different features. You may find you do not need or will not use all of them. This book will give you an understanding of all the features on the Rebel XTi, as well as help you best use those that are most important to you. Don't feel guilty if you don't use every option packed into the camera. On the other hand, remember that you can't "waste film" with digital cameras. Shoot as much as you want and then erase those images that don't work. This means, if you wish, you can literally try out every feature on your camera to see how it functions. This is a quick and sure way of learning to use your camera, and helps you determine which features really are most useful to you.

The Canon EOS Rebel XTi offers a high degree of technological sophistication at an affordable price. In many ways, it sets the bar for all other digital SLRs in this price range. With a sensor that contains 10.1 megapixels, the Rebel XTi shoots 3 frames per second (fps) and up to 27 JPEG (10 RAW) frames consecutively. It also offers quick start-up, fast memory card writing speeds, and other controls that match the performance of many top pro cameras.

Built with a stainless steel chassis, the camera is housed in a polycarbonate body. While more expensive to manufacture, this construction creates a lightweight, yet strong, unit. The exterior of the camera is available in titanium silver or satin black finishes. Other than the finish color there is no difference between the silver or black models.

The Rebel XTi can take JPEG image files, RAW image files, or a combination of both, depending on your needs. If you shoot RAW files, plan to spend time processing them on the computer.

Canon has used its EF-S lens mount for this camera. Introduced with the original Digital Rebel (EOS 300D), this mount accepts all standard Canon EF lenses. In addition, it accepts compact EF-S lenses, built specifically for small-format sensors. These lenses can only be used on cameras designed expressly to accept them.

Compared to the Rebel XT, Canon engineers have redesigned the shape of the grip to improve camera handling. The display is larger and the layout of digital and camera control buttons has been changed, creating an easier to use camera.

Note: When the terms "left" and "right" are used to describe the locations of camera controls, it is assumed that the camera is being held in horizontal shooting position.

The more you shoot pictures, the more comfortable you will become with your Rebel XTi. Knowing your camera makes it easier to take creative and original photos.

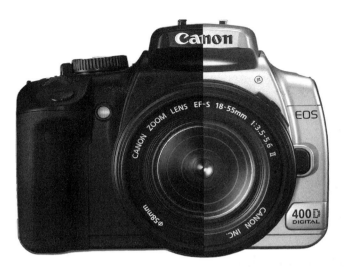

The Rebel XTi is available in both stainless steel and black camera bodies.

Overview of Features

- Canon-designed and Canon-built 10.1 megapixel CMOS sensor; small-format, APS-C size

- The technology of the sensor's pixels and micro-lenses enlarges the light-sensitive portion of each photosite, improving light-gathering capability and signal-to-noise ratio

- New, larger 2.5-inch color display that is brighter and sharper with auto-off sensor

- Shoots 3 fps and up to 27 frames consecutively at maximum JPEG resolution (10 frames continuous in RAW)

- Integrated sensor cleaning system and Canon "Dust Delete Data" detection

- Shutter lag time about 100msec.

- 6 preset Picture Style settings and 3 user-defined custom Picture Style settings

- High-speed shutter, up to 1/4000 sec. with flash sync up to 1/200 sec.

- 9-point autofocus system

- Built-in Cross Keys for easy access to AF (autofocus) points, menus, and other features

- User-activated noise subtraction for long exposures

- Fully compatible with entire EOS system of lenses, flash, and other accessories

- Flexible folder management system, with manual folder creation and up to 9,999 images per folder

- Power-saving design promotes longer battery life

Canon EOS Digital Rebel XTi – Front View

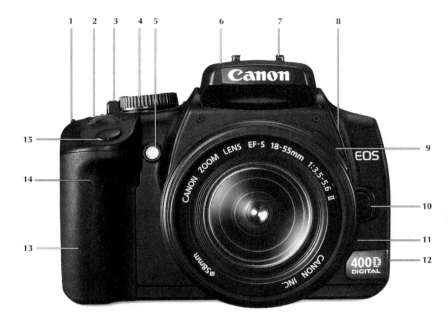

1. Strap mount
2. Main dial ⌒ (page 32)
3. Power Switch (page 34)
4. Mode dial (page 32)
5. Red-eye reduction/Self-timer lamp (page 137)
6. Built-in flash/AF-assist beam (page 102)
7. Hot shoe

8. Flash button ⚡ (page 132)
9. Focus mode switch (on lens)
10. Lens release button
11. Depth-of-field preview button (page 37)
12. Terminal cover
13. Grip
14. Remote control sensor
15. Shutter button (page 32)

Canon EOS Digital Rebel XTi – Back View

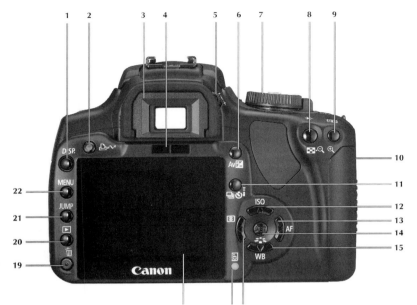

1. Camera setting display on/off/Info/Trimming orientation button DISP. *(page 41)*
2. Print/Share button 凸∿ *(page 172)*
3. Viewfinder eyepiece
4. Display-off sensor *(page 40)*
5. Dioptric adjustment knob *(page 38)*
6. Aperture/Exposure compensation button Av⊠ *(page 123)*
7. Mode dial *(page 32)*
8. AE lock/FE lock button/Index/Reduce button ⚹ ⊠-Q *(page 124)*
9. AF point selection/Enlarge button ⊞ Q *(page 90)*
10. CF card slot cover

11. Drive mode selection button ⊒₁ *(page 105)*
12. ISO speed set button ▲ ISO *(page 106)*
13. AF mode selection button ▶ AF *(page 102)*
14. SET button/Picture Style selection button ⊛ *(page 58)*
15. White balance selection button ▼ WB *(page 65)*
16. Metering mode selection button ◀⊛ *(page 108)*
17. Access lamp
18. LCD monitor *(page 38)*
19. Erase button 🗑 *(page 91)*
20. Playback button ▶ *(page 88)*
21. Jump button JUMP *(page 34)*
22. Menu button MENU *(page 33)*

30

Canon EOS Digital Rebel XTi – Top View

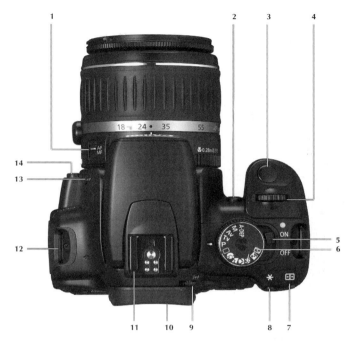

1. *Focus mode switch (on lens)*
2. *Red-eye reduction/Self-timer lamp (page 137)*
3. *Shutter button (page 32)*
4. *Main dial* 🔄 *(page 32)*
5. *Power Switch (page 34)*
6. *Mode dial (page 32)*
7. *AF point selection/Enlarge button* ⊞ ⊕ *(page 90)*

8. *AE lock/FE lock/Index/ Reduce button* ✳ ⊠⊖ *(page 124)*
9. *Dioptric adjustment knob (page 38)*
10. *Viewfinder eyepiece*
11. *Hot Shoe*
12. *Strap mount*
13. *Flash button* ⚡ *(page 132)*
14. *Lens release button*

31

Camera Controls

The EOS Rebel XTi uses icons, buttons, and dials common to all Canon cameras. Specific buttons will be explained with the features they control. The Rebel XTi often uses two controls to manage many of the most common and important functions.

The Mode dial allows you to choose the amount of control you have over the camera; more control in the Creative Zone, or the automatic settings in the Basic Zone (see page 114).

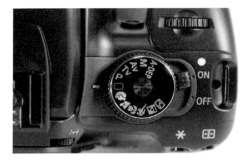

- *Mode Dial* ☺ : Located on top of the camera next to the Power Switch, the Mode dial is used to select various shooting modes. The 12 settings are grouped into two zones: Basic Zone and Creative Zone.

- *Main Dial* 🕸 : Behind the shutter button on the top right of the camera, the Main dial allows you to use your "shooting" finger to set things like exposure. The Main dial works alone when setting shutter speed and aperture. For a number of other adjustments, it works in conjunction with buttons that are either pressed and released, or are held down while the Main dial is turned.

- *Shutter Button*: The Rebel XTi features a soft-touch electromagnetic shutter release. Partially depressing the shutter button activates such functions as autoexposure and autofocus, but this camera is fast enough that there is minimal speed advantage in pushing the button halfway before exposure. It does help, however, when dealing with moving subjects to start autofocusing early, so the camera and lens have time to find your subject.

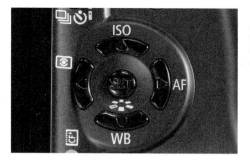

*The Cross Keys oper-
ate as navigational
tools, as well as quick
access to various
modes and menus.*

- **Cross Keys** ✧ : These four keys, arranged in a cross pattern with a centered SET button ⑤ET , are located on the back of the camera, to the right of the LCD. As a group, the keys allow navigation up/down and left/right through menus. In addition, each Cross Key allows quick access to a specific menu item. When the camera is set for picture taking (no menu on the LCD), individual keys provide instant access to AF mode ▶AF , metering mode ◀⊡ , white balance settings ▼WB, and ISO ▲ISO . The SET button ⑤ET provides access to Picture Style settings ⁂ while in this picture-taking mode.

Menus Overview

The Digital Rebel XTi has several menus for capturing and viewing images, as well as setting up the operation of the camera. Once you press the MENU button 𝐌𝐄𝐍𝐔 , located on the back of the camera to the left of the LCD, the menus are displayed on the LCD monitor. The menu structure consists of 5 menu columns. The first two columns, color coded red, are the Shooting menus ◘1 and ◘2 . They deal with image capturing functions. The third column (color coded blue) is the Playback menu ▶ , which allows you to adjust options for displaying images on the LCD, and also control image transfer and printing. The last two columns, color coded yellow, are the Set-up menus ᵞᵀ1 and ᵞᵀ2 , which deal with a variety of camera set-up functions. You can navigate systematically through the menus using the

Cross Keys. The JUMP button **JUMP** (located to the left of the LCD) quickly moves you from one menu to another without having to step through each menu item.

The Rebel XTi powers up in approximately 0.2 seconds, and can be set to turn off automatically after a duration of inactivity to conserve battery power.

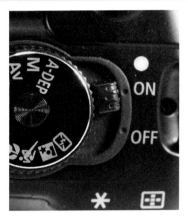

Camera Activation

Power Switch

The Power Switch is found on the top right of the camera next to the Mode dial.

Auto Power Off

All digital cameras automatically shut off after a period of inactivity to conserve power. The Rebel XTi has an Auto power off selection in the Set-up 1 menu **ⓘ1** that can be used to turn off the power after a set duration of idleness spanning from 30 seconds to 15 minutes. If you do not want the camera to turn itself off, set this feature to <OFF> and the camera will remain on as long as the Power Switch is activated.

Auto power off is helpful to minimize battery use, but you may find it frustrating if you try to take a picture and find that the camera has shut itself off. For example, you might be shooting a hockey game and the action may stay away from you for a couple of minutes. If Auto power off is set to <1 min.>, the camera will be off as the players move toward you. When you try to shoot, nothing will happen because the camera is powering back up. You may miss the important shot. In this case, you might want to change the setting to <4 min.> or <8 min.> so that the camera stays on when you need it.

You access the Auto power off function through the camera's menus. Press the MENU button **MENU** (on the back of the camera to the left of LCD) and advance to the Set-up 1 menu **ʔT1** (color code yellow) using the JUMP button **JUMP**. When the Set-up 1 menu is highlighted, use the Up/Down Cross Keys **▲▼** to select <Auto power off>, the first option in this Menu. You will be given seven different choices ranging from 30 seconds to 15 min. (including the Off option that prevents the camera from turning off automatically). Use the Cross Keys to highlight the desired time and the SET button ⑤ET (located in the middle of the Cross Keys) to select it.

Resetting Controls
With all the controls built into the Rebel XTi, it is possible to set so many combinations that at some point you may want to reset everything. You can restore the camera to its original default settings by going to <Clear settings> in the Set-up 2 menu **ʔT2**. You can clear all camera settings or just the Custom Function settings (see page 94).

Canon EOS Digital Rebel XTi – Viewfinder

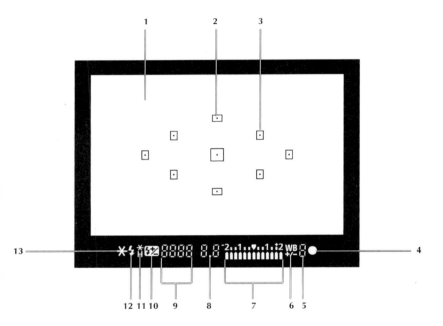

1. Focusing screen
2. AF point display indicator
3. AF point (9 total points)
4. Focus confirmation light
5. Max. burst
6. White balance correction
7. Exposure level indicator
 Exposure compensation
 amount
 Auto Exposure Bracketing
 (AEB) range
 Red-eye reduction lamp
 indicator
8. Aperture
9. CF card full warning
 (FuLL CF)
 CF card error warning
 (Err CF)
 No CF card warning (no CF)

Shutter speed
FE lock (FEL)
Busy (buSY)
Built-in flash recycling
(buSY)
10. Flash exposure
 compensation
11. High-speed sync (FP flash)
 FE lock/FEB in-progress
12. Flash ready
 Improper FE lock warning
13. AE lock
 FE Lock
 AEB in-progress

36

The Viewfinder

The Rebel XTi uses a standard eye-level, reflex viewfinder with a fixed pentamirror. Images from the lens are reflected to the viewfinder by a quick return, semi-transparent half-mirror (there is no cutoff with Canon lenses EF 600mm f/4 IS USM or shorter). The mirror lifts for the exposure, then rapidly returns to keep viewing blackout to a very short period. (Viewfinder blackout time is about 170ms at 1/60 second or faster shutter speeds.) The mirror is also dampened so that mirror bounce and vibration are essentially eliminated. The viewfinder shows approximately 95% of the actual image area captured by the sensor. The eyepoint is about 21 millimeters, which is good for people with glasses.

The viewfinder features a non-interchangeable, precision matte focusing screen. It uses special micro-lenses to make manual focusing easier and to increase viewfinder brightness. The viewfinder provides 0.8x magnification and includes superimposition display optics to make information easy to see in all conditions. The display includes a great deal of data about camera settings and functions, though not all these numbers are available at once. The camera's nine autofocus (AF) points are on the focusing screen, and the solid band at the bottom of the screen shows autoexposure lock, FE lock, flash information, exposure information, maximum burst, CF card information, White balance adjustment, and AF/MF (auto/manual focus) confirmation (a circle appears on the far right when the camera is in focus). Depth of field can be previewed through the viewfinder by using the Depth-of-field preview button, near the lens on the lower-left front of the camera.

There is no eyepiece shutter to block light entering the viewfinder when it is not against the eye (which does affect exposure). However, an eyepiece cover, conveniently stored on the camera strap, is provided instead.

If the AF points do not look sharp when you look through the eyepiece, use the diopter adjustment control.

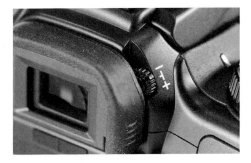

Viewfinder Adjustment

The Rebel XTi's viewfinder features a built-in diopter (a supplementary lens that allows for sharper viewing). The diopter will help you get a sharp view of the focusing screen so you can be sure you are getting the correct sharpness as you shoot. For this to work properly, you need to adjust the diopter for your eye. The adjustment knob is just above the eyecup, slightly to the right. Fine-tune the diopter setting by looking through the viewfinder at the AF points. Then rotate the dioptric adjustment knob until the AF points appear sharp. You should not look at the subject that the camera is focused on, but at the actual points on the viewfinder screen. If you prefer, you can also use the information at the bottom of the screen for this purpose.

Some Canon literature claims you can use this adjustment to see through the camera comfortably with or without eyeglasses, though I have found that the correction isn't really strong enough for most people who wear glasses regularly (like me).

The LCD Monitor

The LCD monitor is probably the one feature of digital cameras that has most changed how we photograph. Recognizing its importance, Canon has put an excellent 2.5 inch (6.35 cm), high-resolution LCD screen in the monitor found on the back of the camera. With about 230,000 pixels, this

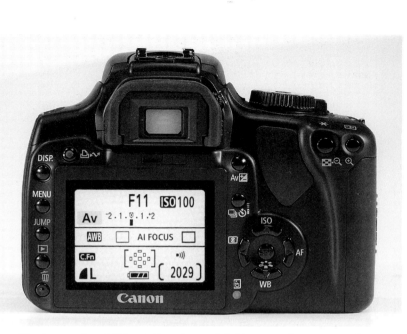

The large, clear LCD monitor gives a bright screen for menu navigation, setting custom functions, and reviewing your images with the Playback function.

screen has excellent sharpness, making it extremely useful for evaluating images.

You can adjust the brightness of the LCD monitor to any of 7 levels. Press the MENU button **MENU** and advance to the Set-up 1 menu **ⁱⁱ1** (color code yellow) using the JUMP button **JUMP**. When it is highlighted, use the Up/Down Cross Keys **▲▼** to select LCD brightness (the third option in the menu), and then press the SET button ⒮ₑₜ . The last image captured, together with a grayscale chart, will appear on the LCD. There is a sliding scale that you can adjust with the Left/Right Cross Keys **◀▶** . Once you have selected the brightness setting you want, press the SET button ⒮ₑₜ to select it and exit the brightness setting menu.

The LCD monitor in the Rebel XTi can also display a graphic representation of exposure values, called a histogram (see pages 111-112). The ability to see both the recorded picture and an exposure evaluation means that under- and over-exposures, color challenges, lighting problems, and compositional issues can be dealt with on the spot. Flash photography in particular can be checked, not only for correct exposure, but also for other factors such as the effect of lighting ratios when multiple flash units and/or reflectors are used. No Polaroid film test is needed. Instead, you can see the actual image that has been captured by the sensor.

In addition, the camera will rotate images in the LCD monitor. Some photographers love this feature, some hate it, but you have the choice. The Auto-rotate function (see page 90) displays vertical images properly without holding the camera in the vertical position . . . but at a price. The image will appear smaller on the LCD. On the other hand, turning the Auto-rotate feature <Off> keeps the image as big as possible, but it appears sideways in the LCD.

You can also magnify an image 10x in the monitor in 15 steps and the enlarged photo is scrollable (using the Cross Keys) so you can inspect all of it. While the image is magnified, you can use the Main dial 🖐 (on the top front of the camera) to scroll back and forth through your other images. This way you can compare details in images without having to re-zoom in on the image.

New to the XTi is the camera settings display on the LCD. When not in menu mode or playing back an image, the LCD shows the current camera settings. It is designed to display shooting information and is always operational when the camera is on. It displays camera details, including exposure, white balance, drive settings, metering type, focusing type, resolution, and much more.

While this display is always on when the camera is on, a new display-off sensor below the viewfinder turns off this display when you bring the camera up to your eye for shoot-

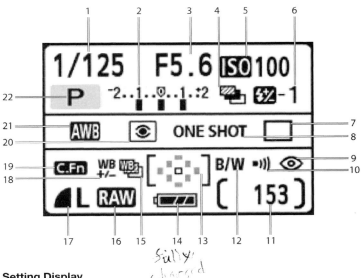

fully
charged

Setting Display

1. Shutter speed
2. Exposure level indicator
3. Aperture
4. Autoexposure Bracketing (AEB)
5. ISO speed
6. Flash exposure compensation
7. Drive mode
8. AF mode
9. Red-eye reduction
10. Beeper
11. Shots remaining
 Shots remaining during WB bracketing
 Self-timer countdown
12. Monochrome shooting
13. AF point selection
14. Battery check
15. White balance bracketing
16. File format
17. Image-recording quality
18. White balance correction
19. Custom Function
20. Metering mode
21. White balance
22. Shooting mode

ing. This saves power and minimizes distraction when looking through the viewfinder. The sensor works by emitting infrared light that is reflected back to an infrared sensor by any object that passes close to the viewfinder. To save power, you can also turn of the display manually by using the DISP. Button **DISP.** .

Powering the Camera

The Rebel XTi has several power options. The most commonly used is the 720mAh NB-2LH, a compact nickel metal hydride (NiMH) rechargeable battery, which is smaller and lighter than the older BP-511 and BP-512. Milliamp Hours (mAh) indicate a battery's capacity to hold a charge. Higher mAh numbers usually mean longer-lasting batteries.

Although the camera is designed for efficient use of battery power, it is important to realize that power consumption is highly dependent on how long different features such as flash, autofocus, and the LCD are used. The more the camera is active, the shorter the battery life, especially with regard to use of the LCD and built-in flash. Be sure to have backup batteries. And it is always a good idea to shut the camera off if you are not using it.

Canon estimates that at 73°F (23°C), the battery will last approximately 500 shots when flash is not used, or 360 shots when flash is used 50% of the time. Lower temperatures will reduce the number of shots. In addition, it is never wise to expose your camera or its accessories to heat or direct sunlight (i.e., don't leave the camera sitting in your car on a hot or a cold day!). The NB-2LH is rated at 7.4 volts and it takes about 90 minutes to fully charge on the CB-2LW charger that is included with the camera.

The Battery Grip BG-E3 attaches to the bottom of the camera and can be used with one or two NB-2LH batteries. If two batteries are loaded, power is initially drawn from the battery having the higher voltage. Once the voltage level of the two batteries is the same, power is drawn from both packs.

The grip also has an adapter, BGM-E3A, which allows six AA-size batteries to be used. It includes a Vertical-grip shutter button, AE lock button, and AF point selection button, as well.

The AC Adapter Kit (ACK-DC20) is useful to those who need the camera to remain consistently powered up (i.e., for scientific lab work). You can charge the battery in the car using the CBC-NB2 12V charger.

Date/Time

Date and time are established by going into the Set-up 1 menu **𝐘𝐓1** . Next use the Up/Down Cross Keys ▲▼ to select Date/Time. Press the SET button ⓢⓔⓣ in the center of the Cross Keys to enter the adjustment mode. Once there, use the Up/Down Cross Keys ▲▼ to adjust the date, time and/or format of the date/time display and the SET button ⓢⓔⓣ to advance from date to time, etc. Once the date and time are correct, press the SET button ⓢⓔⓣ again to enter your selections and exit the adjustment mode.

A special lithium battery inside the battery compartment holds the date and time memory. The life of this battery is about 5 years. It is easy to replace: simply slide the battery holder out and put in a new battery. You'll know when to replace the battery if the date and time are reset when you change the regular battery.

The Sensor

The Rebel XTi has a newly designed 10.1 megapixel sensor (3888 x 2592 pixels), which is remarkable in a camera of this class, especially given the Rebel XTi's price and speed. It can easily be used for quality magazine reproduction across two pages.

Because the Rebel XTi's APS (Advanced Photo System)-sized CMOS sensor (22.2 x 14.8 mm) covers a smaller area (small-format sensor) than a 35mm film frame, it records a narrower field of view than a 35mm film camera. To help photographers who are used to working with 35mm SLRs visualize this narrower field of view, a magnification factor of 1.6 is

applied to the lens focal length. Thus, on the Rebel XTi, a 200mm lens will have a field of view similar to that of a 320mm lens on a 35mm camera. Remember, the focal length doesn't change, just the view seen by the Rebel XTi's sensor.

This magnification factor is great for telephoto advocates because a 400mm telephoto acts like a 640mm lens on a 35mm camera. However, it causes a problem at the wide-angle end, where a 28mm lens acts like a 45mm lens. A fairly wide lens loses most of its wide-angle capabilities.

Wide angles of view can be difficult to get with small-format sensors. The Rebel XTi accepts Canon EF-S lenses, which are specially designed just for this size image sensor. They include a 10-22mm zoom that offers an equivalent 16-35mm focal length.

Though small-format, the sensor in the Rebel XTi demonstrates improvements in sensor technology. It adds nearly 25% more pixels than the Rebel XT, on the same size image sensor. So obviously each pixel has to be smaller. In the past, this would have meant problems with noise, sensitivity, dynamic range and reduced continuous shooting speed. However, this sensor's 10.1 megapixels offer the same signal-to-noise, ISO range, and dynamic range as the XT. The continuous shooting speed has also stayed the same even though the file size has increased.

Low noise characteristics are extremely important to advanced amateur and professional photographers who want the highest possible image quality. The Rebel XTi gives an extraordinarily clean image with exceptional tonalities and the ability to be enlarged with superior results.

Several other factors contribute to the improved imaging quality. Canon has worked hard on the design and production of its sensors. The microlens configuration has been improved to increase light-gathering ability, improve light convergence, and reduce light loss. The area that is sensitive to light on each pixel has also been increased.

The Rebel XTi's impressive sensor gives superior image results, even when shooting in low-light or nighttime situations.

In addition, the camera has an improved low-noise, high-speed output amplifier as well as power-saving circuitry that also reduces noise. With such low noise, the sensor offers more range and flexibility in sensitivity settings. ISO settings range from 100-1600.

The on-chip RGB primary color filter uses a standard Bayer pattern over the sensor elements. This is an alternating arrangement of color with 50% green, 25% red, and 25% blue; full color is interpolated from the data. In addition, an infrared cut-off, low-pass filter is located in front of the sensor. This two-part filter is designed to prevent the false colors and the wavy or rippled look of surfaces (moiré) that can occur when photographing small, patterned areas with high-resolution digital cameras.

Mirror Lockup

For really critical work on a tripod, such as shooting long exposures or working with macro and super telephoto lenses, sharpness is improved by eliminating the vibrations caused by mirror movement. This is accomplished by locking up the mirror in advance using the Rebel XTi's mirror lockup function. However, it also means the viewfinder will be blacked out and the drive mode will be One-Shot.

Mirror lockup is set with Custom Function 7 (see page 94). Once set, the mirror will lock up when the shutter button is pressed. Press the shutter button again to make the exposure. If, after 30 seconds, you haven't pressed the shutter, the mirror will flip back down.

Use a remote switch or the self-timer to keep all movement to a minimum. With the self-timer, the shutter will go off two seconds after the mirror is locked up, allowing vibrations to dampen. When using the self-timer with Bulb exposure and mirror lockup, you must keep the shutter depressed during the two-second self-timer countdown, otherwise you will hear a shutter sound but the image will not be captured.

Memory Cards

The Canon EOS Rebel XTi uses CompactFlash (CF) memory cards. You will need a sizeable card to handle the image files of this camera; anything less than 256 MB will fill up too quickly (see page 74 for specifics). CF cards are sturdy, durable, and difficult to damage. One thing they don't like is heat; so make sure you store them properly.

To remove the memory card from your camera, simply open the Card slot cover on the right side of the body and push the Card eject button at the bottom of the Card slot.

CompactFlash memory cards come in a variety of sizes, and the availability of large card sizes is increasing rapidly.

Caution: Before removing the memory card, it is a good idea to turn the camera off. Even though the Rebel XTi will automatically shut itself off when the memory card door is opened, make sure the Access lamp near the bottom right of the LCD is not illuminated. This habit of turning the camera off will allow the camera to finish writing to the card. If you should open the card slot and remove the card before the camera has written a set of files to it, there is a good possibility you will corrupt the directory or damage the card. You may lose not only the image being recorded, but also, potentially all of the images on the card.

You have three choices in how the camera numbers the images on the card. They can go continuously from 0001 to 9999 even when you change cards, or the camera can reset numbers every time you change cards. Or you can manually reset the numbering.

The continuous file numbering option stores all of the images in one folder on the card. Once image 9999 is recorded, you will get a message, "Err CF." At that point you have to replace the CF card or change the numbering options.

Note: Even if you delete images the maximum number for an image is 9999. With the Auto-reset option, numbering is reset to 0001 and a new folder is created each time the memory card is inserted into the camera. The manual reset option allows you to create a new folder and reset the file numbering to 0001. The maximum number of folders is 999. At 999, you will get a message, "Folder number full" on the LCD.

There is no advantage to a particular method of number-ing; it is a personal preference depending on how you want to manage your images. Continuous numbers can make it easy to track image files over a specific time period. Creat-ing folders and resetting numbers will let you organize a shoot by location or subject matter. To select Continuous, Auto reset, or Manual reset go to the Set-up 1 menu ⚙1 and select <File numbering>.

Formatting Your Memory Card

Caution: Formatting will erase all images and information stored on the card, including protected images. Be sure that you do not need to save anything on the card before you for-mat. (Transfer important images to a computer or other downloading device before formatting the card.)

Before you use a memory card in your camera, it must be formatted specifically for the Rebel XTi. To do so, go to the Set-up 1 menu ⚙1 , and then highlight <Format> using the Up/Down Cross Keys ▲▼ . Press the SET button (SET) and the Format menu will appear on the LCD. It will tell you how much of the card is presently filled with images and how big the card is. Use the Cross Keys to move the choice to <OK>, press the SET button (SET) , and formatting will occur. You will see a screen showing the progress of the for-matting. Keep in mind that formatting will erase all of the images on the card, whether they were previously protected or not!

It is important to routinely format a CF card to keep its data structure organized. However, never format the card in a computer because it uses different file structures than digi-tal cameras and may make the card unreadable for the cam-era, or may cause problems with your images.

Cleaning the Camera

A clean camera minimizes the amount of dirt or dust that could reach the sensor. A good kit of cleaning materials should include the following: a soft camel hair brush to clean off the camera, an antistatic brush and micro-fiber cloth for cleaning the lens, a pack towel for drying the camera in damp conditions (available at outdoor stores), and a small rubber bulb to blow debris off the lens and the camera.

Always blow and brush debris from the camera before rubbing with any cloth. For lens cleaning, blow and brush first, then clean with a micro-fiber cloth. If you find there is residue on the lens that is hard to remove, you can use lens-cleaning fluid, but be sure it is made for camera lenses. Never apply the fluid directly to the lens, as it can seep behind the lens elements and get inside the body of the lens. Apply with a cotton swab, or just spray the edge of your micro-fiber cloth. Rub gently to remove the dirt, and then buff the lens with a dry part of the cloth, which you can wash in the washing machine when it gets dirty.

You don't need to be obsessive, but remember that a clean camera and lens help ensure that you don't develop image problems. Dirt and residue on the camera can get inside when changing lenses. If these end up on the sensor, you will have image problems. Dust on the sensor will appear as small, dark, out-of-focus spots in the photo (most noticeable in light areas, such as sky). You can minimize problems with sensor dust if you turn the camera off when changing lenses (that keeps a dust-attracting static charge from building up). Keep a body cap on the camera and lens caps on lenses when not in use. You should regularly vacuum your camera bag so that dust and dirt aren't stored with the camera.

Canon has introduced a new system to combat the dust that is inherent with cameras with removable lenses. This two-prong approach utilizes a self-cleaning sensor unit and software for detecting dust in captured images.

The low-pass filter in front of the sensor is attached to a piezoelectric element that rapidly vibrates at camera power-up and power-down. Cleaning at power-down is useful to prevent dust from sticking to the sensor when the camera sits for long periods of time.

Self-cleaning can be enabled and disabled under setup menu 2 ¶T2 . Using the Cross Keys select Sensor cleaning: Auto. Press the SET button (SET) . Then select <Set up> and press the SET button (SET) . From there you can choose to enable or disable self-cleaning. Also in this menu item you can engage the self-cleaning function immediately.

Note: In order to prevent overheating, the self-cleaning operation cannot be engaged within 3 seconds of any other operation. It will also stop working if it is run 5 times within 10 seconds. After a brief delay (usually 10 seconds) it will be available for use.

In the event that there is still dust on the sensor, the Rebel XTi's Dust Delete Data feature can be used. By photographing an out-of-focus solid white patternless object (such as a white sheet of paper) the image sensor is able to detect the shadow cast by dust stuck to the low-pass filter. Coordinates of the dust are embedded in the image metadata. Canon's Digital Photo Professional version 2.2 can use this data to automatically remove the dust spots in the image.

Manually Cleaning the Sensor
The Rebel XTi allows you to clean the sensor, but there are precautions to be taken. You must do this carefully and gently, indoors and out of the wind—and at your own risk! Your battery must be fully charged so it doesn't fail during cleaning (or you can use the optional AC adapter). The sensor unit is a precision optical device, so if the gentle cleaning described below doesn't work, you should send the camera to a Canon Service Center for a thorough cleaning.

To clean the sensor, turn the camera on and go to the Set-up 2 menu ¶T2 . Using the Up/Down Cross Keys ▲▼ ,

highlight Sensor cleaning: Manual. Press the SET button ⓢⒺⓣ and follow the instructions. You'll be given <OK> and Cancel options. Using the Left/Right Cross Keys ◀▶, select OK and press the SET button ⓢⒺⓣ. The LCD turns off, the mirror will lock up, and the shutter will open. Take the lens off. Then, holding the camera face down, use a blower to gently blow any dust or other debris off the bottom of the lens opening first, then off the sensor. Do not use brushes or compressed air because these can damage the sensor's surface. Turn the camera off when done. The mirror and shutter will return to normal. Put the lens back on.

Note: Canon specifically recommends against any cleaning techniques or devices that touch the surface of the imaging sensor.

Caution: Never leave a digital SLR without a body cap for any length of time. Lenses should be capped when not in use and rear caps should always be used when a lens is not mounted. Also, make sure you turn off the camera when you change lenses. These practices will help to prevent dust from reaching the sensor.

Getting Started in 10 Basic Steps

There are ten things you should check in order to make your work with the camera easier from the start. These steps are especially useful if you have not yet become familiar with the camera. You will probably modify them with experience.

1. *Set Auto power off for a reasonable time.* The camera comes with a very short power-off setting. I guarantee this will frustrate you when the camera has turned itself off just as you are ready to shoot. Perhaps it is more realistic to try four minutes. Change this time period in the Set-up 1 menu ⓨⓣ1 (see page 85).

2. *Adjust the eyepiece:* Use the Dioptric adjustment knob to the right of the viewfinder to make the focus through

your eyepiece as sharp as possible. You can adjust it with a fingertip. I think it is easiest to adjust when the camera is on. Lightly press the shutter button to display viewfinder information. Focus on the AF (autofocus) points and on the letters in the viewfinder information. Never try to make this adjustment by focusing on a scene that is imaged by the lens (see page 38).

3. **Customize the SET button** (SET) **:** By using one of the Custom Functions (see page 94), the SET button (SET) can be programmed to quickly access one of several key camera settings, such as Image quality, Autofocus and Picture Style.

4. **Choose an image size of L (JPEG) or RAW:** This determines your image file quality. You choose this at the top of the Shooting 1 menu ◘1 , and use the Cross Keys ✧ or the Main dial to select your desired image size (see page 79).

5. **Set your preferred shooting mode:** Use the Mode dial on the top of the camera to select any of the Basic Zone's presets (see pages 114-116) or one of the Creative Zone's settings: P, Tv, Av, M, or A-DEP (see pages 117-124). If using any of the Creative Zones, select a Picture Style by pressing the SET button (SET) and then use the Cross Keys ✧ to select the style (see page 117).

6. **Select a Drive mode:** Drive is selected by pressing the Drive mode selection button located just to the right of the LCD (when a menu isn't being displayed). Use the Cross Keys ✧ to select either Single shooting, Continuous shooting, or Self-timer/remote control. The LCD will indicate which mode the camera is in (see page 105).

7. **Choose AF mode:** Autofocus (AF) mode is set by pressing the Right Cross Key ▶AF when a menu isn't displayed on the LCD. The LCD monitor will then display several AF mode options. Use the Left/Right Cross Keys ◀▶

and the SET button ⑤ET to choose an appropriate mode. The selected mode will be displayed on the camera settings display on the LCD. A good place to start on this camera is AI Servo AF (see page 102).

8. *Select white balance (WB):* Auto WB is a good place to start because the Rebel XTi is designed to generally do well with it. To set, press Down Cross Key ▼ WB—the different white balance choices will display on the LCD. Use the Left/Right Cross Keys ◄► and the SET button ⑤ET to select the desired white balance. The mode selected will appear on the camera settings display on the LCD (see pages 64-69).

9. *Pick an ISO setting:* With the Rebel XTi, you can get away with higher settings than with other digital cameras. Anything between 100 and 400 will work beautifully. Press the Up Cross Key ▲ ISO and use the Cross Keys ✛ to highlight the choice for ISO speed. Use the SET button ⑤ET to make your selection. The mode selected will appear on the camera settings display on the LCD (see pages 106-108).

10. *Set camera for reasonable review time:* This camera comes with a default review time (the period of time the picture is displayed on the LCD monitor after taking the photo) that is quite short—merely two seconds. That's not enough time to analyze anything. I recommend the eight-second setting, which you can always cancel by pressing the shutter release. If you are worried about using too much battery power, just turn off the review function altogether. Go to the Playback menu ▶ to change the review time (see page 88).

Note: The Main dial 🔄 can often be used to cycle through menu options instead of the Cross Keys.

53

In-Camera Processing and File Formats

There has been a mistaken notion that JPEG is a file format for amateur photographers while RAW is a format for professionals. This is really not the case. Pros use JPEG and some amateurs use RAW. (Technically, JPEG is a compression scheme and not a format, but the term is commonly used to denote format and that is how we will use it.)

There is no question that RAW offers some distinct benefits for the photographer who needs them, including the ability to make greater changes to the image file before the image degrades from over-processing. The Rebel XTi's RAW format (called CR2 and originally developed by Canon for the EOS-1D Mark II) includes revised processing improvements, which make it more flexible and versatile for photographers than previous versions. It can also handle more metadata and is able to store processing parameters for future use.

However, RAW is not for everyone. It requires more work and more time to process than other formats. For the photographer who likes to work quickly and wants to spend less time at the computer, JPEG may offer distinct advantages and, with the Rebel XTi, even give better results. This might sound radical considering what some "experts" say about RAW in relation to JPEG, but I suspect they have never shot an image with an EOS Rebel XTi set for high-quality JPEGs.

◁ *The ability to shoot RAW files offers the opportunity for more image control, but also requires further image processing on a computer. JPEG files offer high-quality images without the hassle of post-camera processing.*

Canon has long had exceptionally strong in-camera processing capabilities, because of their unique DIGIC Imaging Engine (DIGIC for short). The reason the Rebel XTi delivers such exceptional images using JPEG is that Canon's latest version of their high-performance processor, called DIGIC II, builds on the technology from its predecessors.

DIGIC II intelligently translates the image signal as it comes from the sensor, optimizing that signal as it is converted into digital data. In essence, it is like having your own computer expert making the best possible adjustments as the data file is processed for you. DIGIC II works on the image in-camera, after the shutter is clicked and before the image is recorded to the memory card, improving color balance, reducing noise, refining tonalities in the brightest areas, and more. In these ways it has the potential to make JPEG files superior to unprocessed RAW files, reducing the need for RAW processing.

It is amazing that the DIGIC II handles data so fast that it does not impede camera speed. The Rebel XTi has a single chip with image data processing that is appreciably faster than earlier units. Color reproduction of highly saturated, bright objects is also considerably improved. Auto white balance is better, especially at low color temperatures (such as tungsten light). In addition, false colors and noise, which have always been a challenge of digital photography, have been reduced (something that RAW files cannot offer). The ability to resolve detail in highlights is also improved.

DIGIC II also improves the Rebel XTi's ability to write image data to the memory card in both JPEG and RAW. Write speed is faster, enabling the camera to take advantage of the benefit offered by high-speed memory cards. It is important to understand that this does not affect how quickly the camera can take pictures. Rather, it affects how fast it can transfer images from its buffer (special temporary memory in the camera) to the card. It won't change the shots per second, but it will improve the quantity of images that can be taken in succession.

The Rebel XTi's DIGIC II processor is noticeably faster than previous digital cameras, and lets the photographer get a quick shot of even the shyest of subjects.

Speed

There are factors, however, that do affect how many shots per second the camera can take. Having a high-megapixel sensor with its comparatively large amount of data has usually meant a slower camera. Yet, this is not true of the Rebel XTi. It can take pictures at a speedy 3 frames per second (fps). Even at maximum resolution, the camera has a burst duration of 27 JPEG or 10 RAW frames, or 8 RAW + Large/Fine JPEGs (this will occur only with the fastest memory cards). It is even designed to keep up with autofocus. The camera, itself, has very fast response times: 0.2-second startup (which is 10 times faster than the original Digital Rebel), 100-millisecond (ms) lag time for shutter release, and finder blackout (when the mirror is up during shutter speeds of 1/60 and faster) of only 170 ms.

During Continuous shooting drive mode, each image is placed into a buffer before it is recorded to the memory card. The faster the memory card is, the faster the buffer will be emptied, allowing more images to be taken in sequence. If the buffer becomes full, you will see a "buSY" message in the viewfinder, and the camera will stop shooting until the card writing can catch up.

Picture Style *creative zone*

In addition to the optimizing technology of DIGIC II, you can choose a Picture Style to control how the camera will perform some additional image processing. This can be especially helpful if you are printing image files directly from the camera without using a computer, or when you need to supply a particular type of image to a client. Some photographers compare Picture Styles to choosing a particular film for shooting. Picture Styles are applied permanently to JPEG files. (If using RAW files, the Picture Style can be changed during "processing" using Canon's Digital Photo Professional software.)

You gain access to Picture Styles by pressing the SET button (SET) / ∗∷ (unless SET has been customized to another function), and then using the Up/Down Cross keys ▲▼ to select the Picture Style you wish to use.

If the SET button has been customized or you wish to adjust the Picture Styles settings, use the Shooting 2 menu ◻2 . Press the MENU button MENU ; then use the JUMP button to advance to the Shooting 2 menu. Use the Down Cross Key ▼ WB (or 🔆) to highlight Picture Style, and then press the SET button. Use the Up/Down Cross Keys ▲▼ and SET button (SET) to further highlight and select among the six different Picture Style options and User Defined options. To return to the Shooting menu screen at any time, press the MENU button again. To make further adjustments to a particular Picture Style use the JUMP button.

All of the Picture Styles (except Monochrome) control the degree of processing applied to four aspects of an image:

- Sharpness refers to the amount of sharpening that is applied to the image file by the camera.
- Contrast will increase or decrease the contrast of the scene that is captured by the camera.
- Saturation influences color richness or intensity.
- Color tone helps the photographer decide how red or how yellow to render skin tones, but will also affect other colors.

For Monochrome (black-and-white), the parameters are:
- Sharpness
- Contrast
- Filter
- Toning

Menu options allow you to further adjust the styles. Sharpness, contrast, saturation, and color tone are represented by a selection point on a slider-type scale. With the exception of Sharpness, the default setting is 0, or no user changes.

The adjustment slider for Sharpness is set up differently than the other sliders. Sharpness is generally required at some point in digital photography to overcome, among other things, the use of a low-pass filter in front of the image sensor to reduce problems caused by the grid of pixels on the image sensor. The low-pass filter introduces a small amount of image blur and image sharpening compensates for this blur. The adjustment slider's setting you see is the amount of sharpness already applied to the style. A setting of zero means that almost no sharpening has been applied to the image. You'll notice that the sharpness parameter's default setting is the only one that changes from Picture Style to Picture Style. Settings that appear in blue indicate changes from the default setting.

The different Picture Styles are:

- **Standard:** This is the default picture style for all the Basic Zone modes except Portrait 🐦 and Landscape 🏔 . During in-camera processing, color saturation is enhanced, and a moderate amount of sharpening is performed on the image. Standard offers a vivid and crisp image with a normal amount of contrast.

- **Portrait:** This is the selected mode for the Portrait 🐦 in the Basic Zone. An emphasis on pleasing skin tones is the goal of this style. While the contrast is the same as Standard, skin tones will have a slightly warmer look. Sharpening is reduced in order to produce a pleasing soft skin texture. ISO 100 not 400

- **Landscape:** This is the selected mode for the Landscape 🏔 in the Basic Zone. Saturation is high, with an emphasis on blues and greens. There is also a boost in saturation in the yellows. The image is sharpened even more than the Standard mode to emphasize details. Don't be afraid to use this during cloudy days to help bring out more color.

- **Neutral:** If you are planning to "process" the image either through Canon's Digital Photo Professional software or some other image editor, this may be the mode to choose. There is virtually no image sharpening. Color saturation is lower than other modes and contrast is lower, too. Since other picture styles increase saturation, Neutral may be a good mode to choose when you are shooting in bright or high-contrast situations. Picture details may be more prevalent with this setting. Don't rule it out for candid portraits that might occur in bright lighting situations.

- **Faithful:** When you need to accurately capture the colors in the scene, then this is the mode. Saturation is low, and almost no sharpening is applied to the image. Contrast is also toned down. Accurate color reproduction is achieved when the scene is lit with 5200K lighting. Otherwise you might think of this setting as similar to

The Basic Zone image settings are helpful for anyone with little time to spare for specific camera settings such as aperture and shutter speed.

Neutral, except that the color tone is a bit warmer rather than Neutral. Like Neutral, this mode is designed with further image processing via computer in mind.

- **Monochrome:** This allows you to record pure black-and-white images to the memory card and to automatically view the image in black-and-white on the LCD. (As with the other picture styles, this changes JPEG files permanently—you can't get the color back.) Sharpness is the same as the Standard mode and contrast is enhanced. In addition, there are Filter effects and Toning effects, both of which offer a list of choices, rather than the slider adjustments.

The parameters for Filter effects offer four tonal effects that mimic what a variety of colored filters do to black-and-white film. A fifth setting, N:None, means that no filter effects are applied. Each color choice in the Filter effect menu will make the colors similar to your color selection look lighter, while the colors opposite your selection on the color wheel will record darker.

Ye:Yellow is a modest effect that darkens skies slightly and gives what many black-and-white aficionados consider the most natural looking grayscale image.

Or:Orange is next in intensity, but is better explained as between yellow and red (below).

R:Red is dramatic, lightening anything that is red, such as flowers or ruddy skin tones, while darkening blues and greens. Skies turn quite striking and sunlit scenes gain in contrast (the sunny areas are warm-toned and the shadows are cool-toned, so the warms get lighter and the cools get darker).

G:Green makes Caucasian skin tones look more natural and foliage gets bright and lively in tone. Of course, the great thing about shooting with the Rebel XTi is that if you aren't sure what these filters will do, you can take the picture and see the effect immediately on the LCD monitor.

The camera's toning effect adds color to the black-and-white image so it looks like a toned black-and-white print. Your choices include: N:None, S:Sepia, B:Blue, P:Purple, and G:Green. Sepia and blue are the tones we are most accustomed to seeing in such prints.

User Def. 1-3: Each User Def. allows you to take a "base setting" of a particular Picture Style and modify it to meet your own photographic needs. This allows you to create and register a different set of parameters you can apply to image files while keeping the preset Picture Styles.

Each Picture Style parameter is flexible. Select the picture style you want to adjust in 📷2 , press SET (SET) . Press Jump **JUMP** to go to the detail setting of the style you have chosen. Use Up/Down Cross Keys ▲▼ to select the parameter that you want to adjust. Press SET (SET) to enter adjustment mode. The blue indicator shows the current setting. The gray arrow shows the default setting for that style. Use the Left/Right Cross Keys ◄► to adjust the parameter. You must use (SET) to accept the setting. If you leave this menu screen without pressing (SET) , the adjustment will be cancelled. There is also a Default set button at the bottom of the screen. Use this to reset the picture style to its factory setting. Use the MENU to return to the Picture style menu.

While specific situations may affect where you place your control points for these flexible options, here are some suggestions to consider:

Create a hazy or cloudy day setting: Make one of the user-defined sets capture more contrast and color on days where contrast and color are weak. Increase the scale for Contrast and Saturation by one or two points (experiment to see what you like when you open the files on your computer or use the camera for direct printing). You can also increase the red setting of Color tone (adjust the scale to the left).

Create a portrait setting: Make a set that favors skin tones. Start with the Portrait style as your base, then reduce Contrast by one point while increasing Saturation by one point (this is very subjective—some photographers may prefer less saturation) and warming skin tones (by moving Color tone toward the red — or left — side) by one point.

Create a Velvia (an intensely colored slide film) look: Start with Standard style, increase Contrast two points, Sharpness one point, and Saturation by two points.

***You can also download custom picture styles from Canon's
Picture Style website:***

http://www.canon.co.jp/Imaging/picturestyle/index.html

These custom styles can be uploaded into any of the XTi's
3 User-defined styles by using the USB connection to the
camera. (Requires Canon's EOS Utility software that is
included with the camera.) The custom styles can also be
used with Canon's Digital Photo Professional to change
styles after-the-fact in RAW images.

Note: Downloaded Picture Styles can only be loaded into
the User-defined styles and will be deleted if you reset all
camera settings using Clear settings in **ƮƮ2** .

White Balance

White balance is an important digital camera control. It
addresses a problem that has plagued film photographers for
ages: how to deal with the different color temperatures of
various light sources. While color adjustments can be made
in the computer after shooting, especially when shooting
RAW, there is a definite benefit to setting white balance
properly from the start. The Rebel XTi helps you do this with
an improved Auto white balance setting that makes colors
more accurate and natural than earlier digital SLRs. In addi-
tion, improved algorithms and the DIGIC II processor make
Auto white balance more stable as you shoot a scene from
different angles and focal lengths (which is always a chal-
lenge when using automatic white balance). Further, white
balance has been improved to make color reproduction
more accurate under low lights.

While auto white balance will give excellent results in a
number of situations, many photographers find they prefer
the control offered by presets and custom settings. With
eight separate white-balance settings, plus white-balance
compensation and bracketing, the ability to carefully control

color balance is greatly enhanced in the Rebel XTi. It is well worth the effort to learn how to use the different white-balance functions so you can get the best color with the most efficient workflow in all situations (including RAW). This is especially important in strongly colored scenes, such as sunrise or sunset, which can fool Auto white balance.

The basic settings are simple enough to learn that they should become part of the photography decision-making process. However, they can only be used with the Creative Zone exposure modes (see pages 117-124). The more involved Custom white balance setting is also a valuable tool to understand and use for rendering the truest color in all conditions (see pages 64-69).

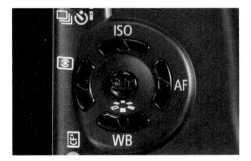

Use the Cross Keys for fast access to camera modes and menus, such as White Balance.

To set white balance when there are no menus displayed on the LCD, press the Down Cross Key ▼ **WB**. A list of choices will appear. Next, use the Left/Right Cross Keys ◀▶ and the SET button (SET) to choose the white balance setting you need.

White balance settings fall within certain color temperature values, corresponding to a measurement of how cool (blue) or warm (red) the light source in the scene is. The measurement is in degrees Kelvin, abbreviated as K—the higher the number, the cooler the light source. Conversely the lower the number, the warmer the light source. See pages 66-68 for descriptions of these settings and their corresponding Kelvin temperatures.

Camera Settings

AWB *Auto:* Color temperature range of approximately 3000-7000K. This setting examines the scene for you, interprets the light it sees (in the range denoted above) using the DIGIC II processor (even with RAW), compares the conditions to what Canon's engineers have determined works for such readings, and sets a white balance to make colors look neutral (i.e., whites appear pure, without color casts, and skin tones appear normal).

Auto can be a useful setting when other family members want to use the camera for snapshots, when you are moving quickly from one type of light to another, or whenever you hope to get neutral colors and need to shoot fast. Even if it isn't the perfect setting for all conditions, it will often get you close enough so that only a little adjustment is needed later using your image-processing software. However, if you have time, it is often better to choose from the white-balance settings listed below, because colors will be more consistent from picture to picture. While Auto is well-designed, it can only interpret how it "thinks" a scene should look, so if your wide-angle and telephoto shots of the same subject change what is seen by the camera in terms of colors, the camera will readjust for each shot, often resulting in inconsistent color from shot to shot.

☀ *Daylight:* Approximately 5200K. This setting adjusts the camera to make colors appear natural when shooting in sunlit situations between about 10 A.M. and 4 P.M. (middle of the day). At other times, when the sun is lower in the sky and has more red light, the scenes photographed using this setting will appear warmer than normally seen with our eyes. This setting makes indoor scenes under incandescent lights look very warm, indeed.

🏠 *Shade:* Approximately 7000K. Shadowed subjects under blue skies can end up very bluish in tone, so this setting warms the light to make colors look natural, with-

out any blue color cast. (At least that's the ideal—individual situations will affect how the setting performs.) The Shade setting is a good one to use anytime you want to warm up a scene (especially when people are included), but you have to experiment to see how you like this creative use of the setting.

Cloudy: Approximately 6000K. Even though the symbol for this setting is a cloud, you might think of it as the Cloudy/twilight/sunset setting. It warms up cloudy scenes as if you had a warming filter, making sunlight appear warm, but not quite to the degree that the Shade setting does. You may prefer the Cloudy setting to Shade when shooting people, since the effect is not as strong. Both settings actually work well for sunrise and sunset, giving the warm colors that we expect to see in such photographs. However, the Cloudy setting offers a slightly weaker effect. You really have to experiment a bit when using these settings for creative effect. Make the final comparisons on the computer.

Tungsten light: Approximately 3200K. Tungsten light is designed to give natural results with quartz lights (generally balanced to 3200K). It also reduces the strong orange color that is typical when photographing lamp-lit indoor scenes with daylight-balanced settings. Since this control adds a cold tone to other conditions, it can also be used creatively for this purpose (to make a snow scene appear bluer, for example).

White fluorescent light: Approximately 4000K. The Auto setting often works well with fluorescents but, under many conditions, the White fluorescent light setting is more precise and predictable. Fluorescent lights usually appear green in photographs, so this setting adds magenta to neutralize that effect. (Since fluorescents can be extremely variable, and since the Rebel XTi has only one fluorescent choice, you may find that precise color can only be achieved with the Custom white balance setting.) You can also use this setting creatively anytime you

wish to add a warm pinkish tone to your photo (such as during sunrise or sunset).

4 *Flash:* Approximately 6000K. Light from flash tends to be a little colder than daylight, so this warms it up. According to Canon tech folks, this setting is essentially the same as Cloudy (the Kelvin temperature is the same); it is simply labeled differently to make it easy to remember and use. I actually use both Flash and Cloudy a lot, finding them to be good, all-around settings that give a slight but attractive warm tone to outdoor scenes.

⚲ *Custom:* Approximately 2000-10,000K. A very important tool for the digital photographer, Custom is a setting that even pros often don't fully understand. It is a very precise and adaptable way of getting accurate or creative white balance. It has no specific white balance K temperature, but is set based on a specific neutral tone in the light in the scene to be photographed. However, it deals with a significantly wider range than Auto. That can be very useful.

The Custom ⚲ setting lets you choose a white (or gray) target on which the camera will white balance. First, take a picture of something white (or a known neutral tone) that is in the same light as your subject. You can use a piece of paper or a gray card. It does not have to be in focus, but it should fill the image area. (Avoid placing the card on or near a highly reflective colored surface.) Be sure the exposure is set to make this object gray to light gray in tone, and not dark (underexposed) or washed out white (overexposed).

Tip: I like to use a card or paper with black print on it rather than a plain white card. This way, if I can see the type, I haven't overexposed the image.

Next, go to the Shooting 2 menu 📷2 , use the Up/Down Cross Keys ▲▼ to highlight Custom WB and push the SET button ⑤ⓔⓣ . The last shot you took (the one for white balance) should be displayed in the LCD monitor. Otherwise,

use the Up/Down Cross Keys ▲▼ to choose the image you shot of the white or gray object. Push SET ⓢⒺⓉ again and the Custom white balance will be set to measure that stored shot. A note appears, "Change WB to Custom WB," as a reminder. This is reminding you that there is one more step to this process: you still need to choose the Custom setting for white balance.

Exit the menu by either pressing **MENU** or depressing the shutter halfway. Press ▼ **WB** then use ◄► to select the far right white balance setting (custom) ◣▨ and then press ⓢⒺⓉ . The camera is now set for your Custom white balance. You could have a series of white balance reference images stored on your memory card ahead of time that you can flip through. This is useful if you need to switch between shooting in different rooms but don't have the time to set up a card to capture the image.

The procedure just described produces neutral colors in some very difficult conditions. However, if the color of the lighting is mixed, like a situation where the subject is lit on one side by a window and on the other by incandescent lights, you will only get neutral colors for the light that the white card was in. Also, when shooting in reduced spectrum lights, such as sodium vapor, you will not get a neutral white under any white balance setting.

You can also use Custom white balance to create special color for a scene. In this case, you white balance on a color that is not white or gray. You can use a pale blue, for example, to generate a nice amber color. If you balance on the blue, the camera adjusts this color to neutral, which in essence removes blue, so the scene will have an amber cast. Different strengths of blue will provide varied results. You can use any color you want for white balancing—the camera will work to remove (or reduce) that color, which means the opposite color will become stronger. (For example, using a pale magenta will increase the green response.)

White Balance Correction

The Rebel XTi goes beyond the capabilities of many cameras in offering control over white balance: there is actually a white-balance correction feature built into the camera. You might think of this as exposure compensation for white balance. It is like having a set of color balancing filters in four colors (blue, amber, green, and magenta) and in varied strengths. Photographers accustomed to using color conversion or color correction filters will find this feature quite helpful in getting just the right color.

The setting is pretty easy to manage using the Cross Keys ✧ . First, go to the Shooting 2 menu 📷2 , highlight WB SHIFT/BKT with the Cross Keys ▲▼ and press the SET button 🔘 . A menu screen will appear with a graph that has a horizontal axis from blue to amber (left to right) and a vertical axis from green to magenta (top to bottom). You move a selection point within that graph with the Cross Keys. You will see a visual indication on the graph as you change the position of the selection point and, at the same time, an alphanumeric display is visible in the upper right of the screen showing a letter for the color (B,A,G, or M) and a number for the setting. For photographers used to color-balancing filters, each increment of color adjustment equals 5 MIREDS of a color-temperature changing filter. (A MIRED is a measuring unit for the strength of a color temperature conversion filter.) Remember to set the correction back to zero when conditions change. The LCD will display 🔲 when white-balance correction is engaged.

The Rebel XTi not only allows you to choose the white balance setting you want, but also allows you to customize your own for individual lighting situations. ⇨

White Balance Auto Bracketing

When you run into a difficult lighting situation and want to be sure of the best possible white balance settings, another option is white balance auto bracketing. This is actually quite different than autoexposure bracketing. With the latter, three separate exposures are taken of a scene, whereas with white balance auto bracketing you take just one exposure and the camera processes it to give you three different white balance options.

Note: Using white balance bracketing will slightly delay the recording of images to the memory card. You cannot use white balance bracketing with your image-recording quality set to RAW or RAW+JPEG (see pages 73-81).

White balance auto bracketing is done up to +/- 3 levels (again, each step is equal to 5 MIREDS of a color correction filter). and will be based on whatever white balance mode you have currently selected. You can bracket from blue to amber or from green to magenta. Keep in mind that even at the strongest settings, the color changes will be fairly subtle. A white balance auto bracketing icon on the LCD will appear to let you know that white balance auto bracketing is set.

To access white balance auto bracketing select WB SHIFT/BKT in the Shooting 2 menu 📷2 and press the SET button 🔘 . The graph screen with the horizontal (blue/amber) and vertical (green/magenta) axes will appear on the LCD monitor. Rotate the Main dial 🎛 on the top front of the camera to adjust the bracketing amount: to the right (clockwise) to set the blue/amber adjustment, then back to zero and go to the left (counter clockwise) for green/magenta. (You can't bracket in both directions.) You can also shift your setting from the center point of the graph by using the Cross Keys ✛ . Pressing the SET button 🔘 will accept your settings.

Note: The default for white balance bracketing records an original image at the currently selected white balance setting, then internally creates an additional set of (1) a bluer image and a more amber image, or (2) a magenta and greener image. Remember, unlike exposure bracketing, you only need to take one shot—you do not have to set the drive setting to 🔳 .

The obvious use of this feature is to deal with tricky lighting conditions. However, it has other uses as well. You may want to add a warm touch to a portrait but are not sure how strong you want it. You could select the Cloudy setting ☁ , for example, then use white balance auto bracketing to get the tone you're looking for. (The bracketing will give you the standard Cloudy white-balanced shot, plus versions warmer and cooler than that.) Or, you may run into a situation where the light changes from one part of the image to another. Here, you can shoot the bracket, then combine the white balance versions using an image-processing program. (Take the nicely white-balanced parts of one bracketed photograph and combine them with a different bracketed shot that has good white balance in the areas that were lacking in the first photo.)

RAW and White Balance
Since the RAW format allows you to change white balance after the shot, some photographers have come to believe that it is not important to select an appropriate white balance at the time the photo is taken. While it is true that Auto white balance 🄰🅆🄱 and RAW will give excellent results in many situations, this approach can cause consistency and workflow challenges. White balance choice is important because when you bring CR2 files into software for "processing", the files open with the settings that you chose during initial image capture. Sure, you can edit those settings in the computer, but why not make a good RAW image better by merely tweaking the white balance with minor revisions at the image-processing stage rather than starting from an image that requires major correction? There will be times that getting a good white balance setting is difficult, and this is when the RAW software white balance correction can really be a big help.

● set automatically
○ user selectable

EOS Rebel XTi Functions

▨ Not selectable

Mode Dial		Basic Zone							Creative Zone				
		□	🎭	🏔	🌷	🏃	🌃	🚫	P	Tv	Av	M	A-DEP
Quality	JPEG	○	○	○	○	○	○	○	○	○	○	○	○
	RAW								○	○	○	○	○
	RAW + JPEG								○	○	○	○	○
ISO speed	Auto	●	●	●	●	●	●	●					
	Manual								○	○	○	○	○
Picture Style	Standard	●			●	●	●	●	○	○	○	○	○
	Portrait		●						○	○	○	○	○
	Landscape			●					○	○	○	○	○
	Neutral								○	○	○	○	○
	Faithful								○	○	○	○	○
	Monochrome								○	○	○	○	○
	User Defined								○	○	○	○	○
White balance	Auto WB	●	●	●	●	●	●	●	○	○	○	○	○
	Preset WB								○	○	○	○	○
	Custom WB								○	○	○	○	○
	WB correction								○	○	○	○	○
	WB bracketing								○	○	○	○	○
AF	One-Shot		●	●	●		●		○	○	○	○	●
	AI Servo					●			○	○	○	○	
	AI Focus	●						●	○	○	○	○	
	AF point selection — Auto	●	●	●	●	●	●	●	○	○	○	○	●
	AF point selection — Manual								○	○	○	○	
	AF-assist beam	●	●		●		●		○	○	○	○	○
Drive	Single	●		●	●		●	●	○	○	○	○	○
	Continuous		●			●			○	○	○	○	○
	Self-timer	○	○	○	○	○	○	○	○	○	○	○	○

File Formats

The Rebel XTi records images as either JPEG or RAW files. It is important to understand how the sensor processes an image. It sees a certain range of tones coming to it from the lens. Too much light, and the detail washes out; too little light, and the picture is dark. This is analog (continuous)

Mode Dial		Basic Zone							Creative Zone				
		□	🏞	⛰	🌷	🏃	🌆	🌃	P	Tv	Av	M	A-DEP
Metering mode	Evaluative	●	●	●	●	●	●	●	○	○	○	○	○
	Partial								○	○	○	○	○
	Center-weighted average								○	○	○	○	○
Exposure	Program shift								○				
	Exposure compensation								○	○	○		○
	AEB								○	○	○	○	○
	AE lock								○	○	○		○
	Depth-of-field preview								○	○	○	○	○
Built-in flash	Auto	●	●		●		●						
	Manual								○	○	○	○	○
	Flash off			●		●		●					
	Red-eye reduction	○	○		○		○		○	○	○	○	○
	FE lock								○	○	○	○	○
	Flash exposure compensation								○	○	○	○	○
Color space	sRGB	●	●	●	●	●	●	●	○	○	○	○	○
	Adobe RGB								○	○	○	○	○

information, and it must be converted to digital (which is true for any file format, including RAW or JPEG). The complete data is based on 12 bits of color information, which is changed to 8-bit color data for JPEG, or simply placed virtually unchanged into a 16-bit file for RAW. (A bit is the smallest piece of information that a computer uses—an acronym for binary digit. Data of eight bits or higher are required for true photographic color.) This occurs for each of three different color channels used by the Rebel XTi: red, green, and blue. RAW files have very little processing applied by the camera. The fact that they contain 12-bit color information is a little confusing since this information is put into a file that is actually a 16-bit format.

Both 8-bit and 16-bit files have the same range from pure white to pure black because that range is influenced only by the capability of the sensor. If the sensor cannot capture detail in areas that are too bright or too dark, then a RAW file cannot deliver that detail any better than a JPEG file. It is true that RAW allows greater technical control over an image than JPEG, primarily because it starts with more data (12 bits in a 16-bit file), meaning there are more "steps" of information between the white and black extremes of the sensor's sensitivity range. These steps are especially noticeable in the darkest and lightest areas of the photo. So it appears the RAW file has more exposure latitude and that greater adjustment to the image is possible before banding or color tearing becomes noticeable.

JPEG format compresses (or reduces) the size of the image file, allowing more pictures to fit on a memory card. The JPEG algorithms carefully look for redundant data in the file (such as a large area of a single color) and remove it, while keeping instructions on how to reconstruct the file. JPEG is therefore referred to as a lossy format because technically, data is lost. The computer will rebuild the lost data quite well as long as the amount of compression is low.

It is essential to note that both RAW and JPEG files can give excellent results. Photographers who shoot both use the flexibility of RAW files to deal with tough exposure situations, and JPEG files when they need fast and easy handling of images.

Which format will work best for you? Your own personal way of shooting and working should dictate that. If you are dealing with problem lighting and colors, for example, RAW will give you a lot of flexibility in controlling both. If you can carefully control your exposures and keep images consistent, JPEG will be more efficient.

RAW Exposure Processing
Working with JPEGs is easy and you can do it with any image-processing program. However, not all of these pro-

grams can open RAW files; special software is required to convert from RAW. Canon supplies a dedicated software program with the Rebel XTi called ZoomBrowserEX (Windows) or ImageBrowser (Mac). Both programs are specifically designed for CR2 files and allow you to open and smartly process them. You can also choose other processing programs, such as Phase One's Capture One, which make converting from RAW files easier. These independent software programs are intended for professional use and can be expensive (although some manufacturers offer less expensive solutions). Their advantage tends to be ease-of-use for better processing decisions, although Canon's Digital Photo Professional (DPP), a high-level RAW conversion program included with the camera, is quite powerful.

One disadvantage to using third-party programs is that they may not support Canon's Dust Delete Data system (see page 50) to automatically remove dust artifacts in your images. Also, Picture Styles may not be supported in software other than Canon's.

Finally, another disadvantage of most RAW conversion programs is that they are not integrated into any image-editing software. This means you have to open and work on your photo, then save it and reopen it in an editing program, such as Adobe Photoshop Elements. Adobe met this challenge by including RAW conversion capabilities in Photoshop CS2 and in Photoshop Elements 5.0. This means you can open a RAW file directly in either of these programs, make the conversions, and then continue to work on the file without leaving the program. You may have to update your Photoshop software if you have had it for a while, since the Rebel XTi is new and it may not be supported in your software version. (Check for updates at www.adobe.com.) Workflow is much improved and control over the RAW file is quite good, although some photographers still prefer the conversion algorithms of other programs.

Whatever method you choose to gain access to RAW files in your computer, you will have excellent control over the images in terms of exposure and color of light. There is special metadata (shooting information stored by the camera) in the file, containing the exposure settings you selected at the time of shooting. This is used by the RAW conversion program when it opens an image. You can then change the exposure values without causing harm to the file. Most RAW software allows batch processing, allowing you to adjust a group of photos to specific settings. It can be a very important way to deal with multiple photos from the same shoot.

Improved RAW Conversion Software
While RAW can be important for many photographers, Canon's RAW conversion software left a lot to be desired in the past. Canon has responded to the requests and complaints of photographers by developing a far superior RAW program, Digital Photo Professional (DPP). This software, once optional, is included with the Canon EOS Rebel XTi and speeds processing quite noticeably.

A key new feature is the program's ability to save adjustments to a file that can then be reloaded and applied again to the original or to other RAW files. The program includes a whole range of valuable controls, such as tone curves, exposure compensation, white balance, dynamic range, brightness, contrast, color saturation, ICC Profile embedding, and more. There is also a comparison mode that allows original and edited images to be compared side by side or in a split image.

DPP even has some batch processing features. It can allow continuous work on images while other files are rendered and saved in the background. Once images have been adjusted in DPP, they can be transferred immediately to Photoshop. There is no question that DPP will really help streamline the workflow of any photographer who needs to work with RAW.

Image Size and Quality

The Rebel XTi offers a total of 8 choices for image-recording quality, consisting of combinations of different file formats, resolutions, and compression rates. But let's be straight about this: Most photographers will shoot the maximum image size using the RAW or the highest-quality JPEG setting. There is little point in shooting smaller image sizes except for specialized purposes. After all, the camera's high resolution is what you paid for!

All settings for recording quality are selected in the Shooting 1 menu ◘1 under Quality. Press the SET button (SET) and the JPEG settings appear in the two columns, showing a symbol and a letter. The letter stands for the resolution size of the image file. The most important settings are L (the largest image size for JPEG, 10.1 megapixels) and RAW. RAW is always 10.1 megapixels.

The JPEG symbols also depict the level of compression. The shape with the smooth curve represents the least amount of compression (Fine = better quality), and when combined with L, makes a very high quality image. The symbol with a stair shape illustrates higher compression (Normal = lesser quality), giving a good quality JPEG image, but not as good as the Fine setting.

The Rebel XTi can record both RAW and JPEG simultaneously. This can be useful for photographers who want added flexibility. This setting records images using the same identification numbers, but with different formats designated by their extensions: .jpg for JPEG and .cr2 for RAW. You can then use the JPEG file, for example, for direct printing, quick usage, and to take advantage of the DIGIC II processor. And you still have the RAW file for use when you need its added processing power. (The RAW and JPEG setting cannot be used in the Basic setting mode).

If you find yourself frequently switching between file recording quality settings, you can use Custom Function 1 (see page 95) to increase the functionality of the SET button.

When this function is set you won't have to press the MENU button **MENU** to call up the display and then navigate to the Quality setting. You simply press the SET button ⑤ET and the Quality menu will appear on the LCD monitor. Then it is just a matter of selecting the quality, pressing the SET button ⑤ET and you can start shooting at the new setting.

The RAW file will first appear in your RAW conversion software with the same processing details as the JPEG file (including white balance, color matrix, and exposure), all of which can be easily changed in the RAW software. Though RAW is adaptable, it is not magic. You are still limited by the original exposure, as well as the tonal and color capabilities of the sensor. Simply because RAW gives you more options to control the look of your images, it is not an excuse to become sloppy in your shooting. If you do not capture the best possible file, your results will be less than the camera is capable of producing.

Each recording quality choice influences how many photos can fit on a memory card. Most photographers will be shooting with large memory cards because they will want the space required by the high-quality files on this camera. It is impossible to give exact numbers of how many JPEG images will fit on a card because this compression technology is variable. You can change the compression as needed (resulting in varied file sizes), but remember that JPEG compresses each file differently depending on what is in the photo and how it can be compressed. For example, a photo with a lot of detail will not compress as much as an image with a large area of solid color.

That said, the chart below will give you an idea of how large these files are and how many images might fit on a 512 megabyte (MB) memory card. The figures are based on actual numbers produced by the camera using such a card. (JPEG values are always approximate.) Also, the camera uses some space on the card for its own purposes and for file management, so you do not have access to the entire 512 MB capacity for image files.

You can immediately see one advantage that JPEG gives over RAW in how a memory card is used. The highest-quality JPEG file at the full 10.1 megapixels allows you to store nearly 2.5 times the number of photos compared to what you could when shooting RAW.

Image Size and Card Capacity

Icon	appx. file size	# shots on 512MB card
◢ L	3.3MB	145
◣ L	1.7MB	279
◢ M	2.0MB	245
◣ M	1.0MB	466
◢ S	1.2MB	419
◣ S	0.6MB	790
RAW	8.3MB	58
◢ L RAW	8.3MB + 3.3MB	41

Camera Menus
and the LCD Monitor

Using the Menus

Menus in digital cameras are a necessary evil—there are simply a great number of settings that need to be controlled. Still, in some cameras, menus are not always easy to use. Canon has put a great deal of thought into the design of the Rebel XTi's menus so that they can be used efficiently. In addition, they can be set in 15 different languages.

All menu controls, or items, are found in five menus that are grouped into three categories based on their use. These categories, intuitively named in order of appearance within the menu system, are Shooting 📷 , Playback ▶ , and Set-up 🔧 . You gain access to the Rebel XTi's menu selections whenever you push the MENU button MENU , which is located on the back of the camera to the left of the LCD monitor. At this point, the Shooting 1 menu 📷1 will appear. Move from category to category in one of two ways: push the JUMP button JUMP (also on back of camera to left of LCD monitor) to enter the next menu in order, or use the Left/Right Cross Keys ◀▶ .

Note: The Left/Right Cross Keys will only work when you are at the top of the menu, so the JUMP button is a more reliable way to get from menu category to menu category.

The menus are designated by their icon at the top of the menu screen on the LCD monitor. Once in a menu, use the Up/Down Cross Keys ▲▼ to select desired items and sub items, and press the SET button ⑤ to confirm, or lock-in, these item choices. To "back out of" a menu, press the MENU button MENU .

The Rebel XTi's variety of features—including Auto rotate, ISO speed, and Red-eye reduction—can be controlled through the various camera menus by way of the LCD monitor.

Note: When the camera is first turned on, pressing MENU takes you to the Shooting 1 menu. After that, pressing MENU takes you to the last menu you selected.

Use the MENU and JUMP buttons, located to the left of the LCD monitor, to move through the Rebel XTi's menus.

◻1 Shooting 1 Menu

For items that obviously affect actual photography, this red-coded menu includes the following choices:

<Quality>	(sets image size and resolution, plus RAW)
<Red-eye On/Off>	(sets red-eye reduction)
<Beep>	(signal for controls on or off)
<Shoot w/o card>	(this allows you to test the camera when no memory card is in it)

◻2 Shooting 2 Menu *

<AEB>	(autoexposure bracketing)
<Flash exp comp>	(adjusts flash exposure)
<WB SHIFT/BKT>	(for bracketing and shifting white balance)
<Custom WB>	(manually set white balance)
<Color space>	(sRGB or Adobe RGB)
<Picture Style>	(set up different profiles for processing images in-camera)
<Dust Delete Data>	(capture reference file for dust extraction)

▶ Playback Menu

This blue-coded menu offers several choices used when viewing images on the LCD monitor:

<Protect>	(prevents images from being erased)
<Rotate>	(rotate image so vertical will display vertically)
<Print order>	(specifies images to be printed DPOF)
<Transfer order>	(used for selecting images to be transferred to the computer)
<Auto play>	(automatic "slide show" on LCD monitor changes image every 3 seconds)
<Review time>	(how long image stays on LCD monitor after shot)
<Histogram>	(select between Brightness and RGB histograms)

ℾ1 Set-up 1 Menu

This menu is coded yellow. These are selections to make before shooting:

<Auto power off>	(six time options, as well as off)
<Auto rotate>	(on ▢🖵 /on 🖵 /off)
<LCD brightness>	(five levels)
<LCD auto off>	(selects whether or not to turn LCD off when eye approaches viewfinder)
<Date/Time>	
<File numbering>	(three options)
<Format>	(very important, used to initialize and erase the card)

ℾ2 Set-up 2 Menu

This menu is also coded yellow:

<Language>	(15 options)
<Video system>	(NTSC or PAL)
<Custom Functions> *	(C.Fn)
>Clear settings> *	(make settings go back to default)
<Sensor cleaning:Auto>	(turns auto cleaning off at startup and shutdown – also allows you to manually start a cleaning sequence)
<Sensor cleaning: Manual> *	(locks mirror and opens shutter for manual cleaning)

<Firmware Ver.> * (used when updating camera)
*__Not available in Basic Zone__

Understanding the menu system is necessary in order to fully benefit from using the LCD monitor and the Custom Functions.

The LCD Monitor

The LCD monitor is one of the most useful tools available when shooting digital, giving immediate access to your images. You can set your camera so that the image appears for review on the LCD monitor directly after shooting the picture. It's better than a Polaroid print!

The Rebel XTi's 2.5-inch (63.5 mm) color LCD monitor is much brighter than the monitors of just a couple years ago, but it still takes a little practice to see it well in bright light. You can adjust its brightness in the Set-up 1 menu **IT1** (select <LCD brightness> and use the Cross Keys ✧ and SET button ⑤ET to adjust the brightness level and confirm), but this often makes the image harder to evaluate. The easiest thing to do is shade the monitor in bright light by using your hand, a hat, or your body to block the sun.

When photographers compare a point-and-shoot digital camera with a larger digital SLR, they often notice that the smaller camera's LCD monitor can be turned on while shooting. Digital point-and-shoot cameras have so-called "live" LCD monitors. However, like most other digital SLRs, the Rebel XTi uses a mirror inside the camera that blocks the path of light from subject to sensor in order to direct the image from the lens to the viewfinder. During exposure the mirror flips up, exposing the sensor to light from the image. A live LCD monitor, on the other hand, must be able to see what is coming from the lens at all times in order to "feed" the LCD monitor.

The Playback button allows you to see your image results immediately.

LCD Image Review

The Rebel XTi's LCD monitor, therefore, is used strictly for review and editing. You can choose to instantly review the image you have just shot, and you can also look at all of the images you have stored on your CF card. Most photographers like the instant feedback of reviewing their images because it gives a confirmation that the picture is okay.

You can set the length of time needed to review the images you have just captured. It is frustrating to be examining a picture and have it turn off before you are through. You can set the duration from among several choices that include <2 sec>, <4 sec>, <8 sec>, or <Hold>, all controlled by the <Review time> selection in the Playback menu ▶ (color code blue). You also use this menu item to activate the <Off> option, which saves power by turning off the LCD monitor, but does not allow you to review the images.

A setting of 2 sec is a bit short—I prefer 8 sec. You can always turn the review off sooner by lightly pressing the shutter button. The <Hold> setting is good if you like to study your photos, because the image for review remains on the LCD monitor until you press the shutter button. But be careful. It is easy to forget to turn off the monitor when using this selection, in which case your batteries will wear down.

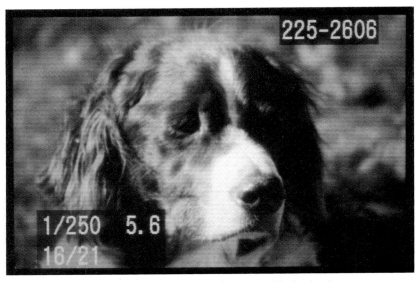

You have the option to review your images with the basic exposure and shooting information (seen above), full shooting information, or with no information.

Note: There is a trick not detailed in the camera manual that lets you "hold" the image even when the duration is not set to <Hold>. As the image appears for review, press the Trash icon 🗑 (for erasing) located near the left corner of the LCD monitor on the back of the camera. This will leave the image on as long as you want (or at least until the Auto power off time in ⵌ11 is reached. Ignore the <OK> and <Cancel> commands. Press the shutter button to turn the review image off.

Playback

Reviewing images on the LCD monitor is an important benefit of digital cameras. To see not only your most immediate shot, but also any (or all) of the photos you have stored on the CF card, press the Playback button ▶ on the back of the camera to the left of the LCD monitor. The last image you captured will display on the LCD monitor. You then

cycle through the photos by using the Left/Right Cross Keys ◄► . If you start by pressing the Left Cross Key, you will move backward through your images chronologically, starting with the most recent one. If you press the Right Cross Key you'll move forward through the images, beginning with the first image on the card.

Note: Camera buttons with blue-colored labels or icons refer to playback functions.

With the Rebel XTi, you can display the review or playback image in three different formats by progressively pushing the DISP. button DISP. , also found on the back of the camera, to the upper left of the LCD monitor. By default, image playback appears in the last display mode you used.

<Display with basic information>: The image for review covers the entire LCD screen and includes superimposed data for folder number, image number, quantity of shots on the CF card, shutter speed, and aperture.

<Display with full shooting information>: A thumbnail of the image is shown with a histogram and expanded data about how the image was shot (white balance, ISO speed, image recording quality, exposure, and much more); this can be very useful for checking what settings are working for you. The thumbnail also includes a Highlight alert function that blinks where areas are overexposed.

<Display with no information>: The image again covers the whole LCD monitor, but the image alone appears, with no additional data about the picture.

Pressing the shutter button halfway will stop playback by turning the LCD monitor off, making the Rebel XTi ready to shoot again. You can also stop the playback and turn the LCD monitor off by pressing the Playback button ▶ .

Note: When the camera is in Menu mode (any menu displayed on the LCD monitor), you can use the DISP. button to show a status display with a whole host of current camera settings. The screen shows Date/Time, Picture Style with Detail parameters, Color space, White balance shift and bracketing values, Auto power off timer setting, Auto rotate setting, LCD auto off and how much space is available on the memory card.

Automatic Image Rotation

The Rebel XTi includes an option to automatically rotate vertical images during review or playback. When <Auto rotate> is on and the camera is held in a horizontal position, images appear up-and-down rather than sideways in the LCD monitor. To select this command go to the Set-up 1 menu ❮1 and use the ✛ and (SET) button to select Auto rotate. Then choose On ❐❏ , again using the ✛ and (SET) button.

You can decide for yourself if you like this feature, but I really don't use it in this setting. Sure, the image is upright and you don't have to rotate the camera to view it. The problem is the size of the image. To get that vertical image to fit in the horizontal frame of the LCD monitor, the picture has to be reduced considerably and becomes harder to see. I like to use the second option, On ❏ . This turns off <Auto rotate> for playing back on the camera, but still lets the computer know that the image should be displayed rotated.

Note: You must turn on <Auto rotate> before you take a picture so that the rotate data gets imbedded in the image file.

Magnifying the Image

You can make the image larger on the LCD monitor by factors of 1.5x to 10x. This feature can be beneficial in helping to evaluate sharpness and exposure details. Press the Enlarge button ❐ ❓ (located on back of the camera in the top right corner) repeatedly to progressively magnify the image. Press the Reduce button ✱ ❐·❓ (located immediately to the left of the Enlarge button ❐ ❓ and marked by a blue magnifier

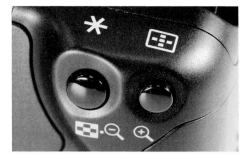

You can use the Enlarge button on the back of the camera to the right of the eyepiece to magnify an image in the LCD monitor.

with minus sign), to shrink the magnification. You can quickly return to full size by pushing the Playback button ▶ .

Use the Cross Keys ✧ to move the magnified image around within the LCD monitor in order to look at different sections of the picture. The Main dial ☼ (just behind the shutter button) will move from one image to another at the same magnified view so you can compare sharpness of a particular detail, for example.

Note: You do not have to be in the <Display with no information> mode to use the magnify feature. For example, if you are using the <Display with full shooting information> mode, pressing the magnify button will move all the data off the screen and zoom into the image.

Erasing Images

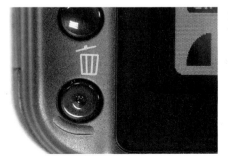

The Trash button gives you the option to erase or save an image while you are reviewing it on the LCD monitor.

The Rebel XTi's process for erasing photos from the memory card is the same as that used by most digital cameras. You can erase images during playback or right after exposure when an image appears in review. When an image is displayed on the LCD monitor, push the Erase button ⌦ , located on the left corner of the LCD monitor. A screen will appear with three options for erasing the image. Use the Left/Right Cross Keys ◄► to highlight the appropriate choice. The first option, <Cancel>, will cancel this function. <Erase>, which is the most commonly used function here, will erase the image being displayed. And finally, <All> is used if you want to delete all unprotected images on the CF card.

See the Note on page 88 for details on using Erase for an extended image preview.

Note: Once an image is erased, it is gone for good. Make sure you no longer want an image before making the decision to erase it.

Image Protection
I consider this feature to be one of a digital camera's most underused and underappreciated functions. At first, it seems like no big deal—why protect your images? You take care of the memory card and promptly download images to the safety of your computer.

But that's not what image protection is about. Its most important function is to allow you to go through your pictures one at a time on the LCD monitor, choosing which ones to keep, or "protect", meaning all the rest can be discarded.

Protection is very easy to use—go to the Playback menu ▶ and select <Protect>. Press the SET button ⓈⒺⓉ and an image will display in the LCD monitor with a key symbol ⊶ next to the word <SET> at the top left of the photo. Next go through your photos one by one using the ✛ . Push the ⓈⒺⓉ button for every one that is a potential "keeper". An icon showing a little key ⊶ will appear at the bottom of the image. Press the MENU button to exit Protection.

Editing your images is easy and convenient with the Rebel XTi. While reviewing an image on the LCD monitor, you can choose to erase or protect it before you transfer the images to a computer.

Once you have chosen the protected images, press the Play button ▶ , followed by the Erase button 🗑 , then select <All> on the erase screen. All the images on the card are erased except the protected ones. You have now performed a quick edit, giving you fewer photos to download and deal with on the computer.

There is often downtime when shooting. Use it to select your photos to edit by "protecting" key shots.

Important: Protecting images does not safeguard them from the "Format" function. When the camera formats the card, ALL of the data on the card will be erased.

TV Playback

If a group of people need to see your photos and you have access to a television with a standard RCA video input connection, you can display images on the TV from the memory card.

First, go to the Set-up 2 menu **ft2** and select the option for Video system. If you are in the US or Canada, be sure to choose <NTSC>. (In many other parts of the world, you will need to select <PAL>.) Make sure both the camera and television are turned off, and then connect the camera to the TV using the cables supplied with the camera. Plug into the Video Out connector on the camera and Video In on the television. Turn the TV on, then the camera. Now press the Playback button **▶** and the image will appear on the TV (but not on the back of the camera).

Note: Some TV's will cut off edges of the image.

Custom Functions

Like most sophisticated cameras, either film or digital, the Rebel XTi can be customized to fit the unique wishes and personality of a photographer. Of course, the selection of exposure modes, type of metering, focus choice, drive speed, picture style, and so forth tailor the camera to a specific photographer's needs. However, the Rebel XTi allows for further customization and personalization to help the camera better fit your personality and style of photography. This is done through the Custom Functions menu. Some photographers never use these settings, while others use them all the time. The camera won't take better photos by changing these settings, but Custom Functions may make the camera easier for you to use.

The Rebel XTi has 11 different built-in Custom Functions (C.Fn), numbered 1-11. They are found in the Set-up 2 menu **ft2** . Use the Up/Down Cross Keys **▲▼** to select <Custom Functions (C.Fn)>, then press the SET button **⊛** to enter the Custom Function screen. Once there,

94

use the Left/Right Cross Keys ◀▶ to navigate to the desired Custom Function, and again press the ⒮ button. Now you have chosen the specific Custom Function, and once again must use the Cross Keys ✦ and ⒮ to select the particular option number (see below) within each Custom Function.

Note: You must press the SET button ⒮ for the camera to accept your change.

A helpful description of the function's purpose appears on the LCD monitor as each option is selected. To exit the Custom Function menus, press the **MENU** button.

Here is a brief summary and commentary on the various Custom Functions. Note that the first selection in each Custom Function is the default setting for the camera.

C.Fn-1 SET function when shooting
This setting assigns new options for using the SET button.

0. <Picture Style>: the SET button brings up the selection screen for Picture Styles.

1. <Quality>: allows you to press the SET button to go directly to recording quality. (This is useful if you want the ability to quickly change from RAW to JPEG). The settings appear in the LCD monitor.

2. <Flash exp comp>: the SET button takes you to the flash exposure compensation screen. (This is useful if you are taking a lot of flash pictures).

3. <Playback>: SET acts like the Playback button (some people find this more convenient).

4. <Cross keys/ AF frame selec.>: allows you to directly select an autofocus point by using the Cross Keys without having to press the Autofocus select button. The SET button will select the center autofocus point.

C.Fn-2 Long exposure noise reduction

This setting engages automatic noise reduction for long exposures. When noise reduction is used, the processing time of the image is a little more than twice the original exposure. For example, a 20 second exposure will take an additional 20 seconds to complete.

0. <Off>: Long exposure noise reduction is turned off.

1. <Auto>: Noise reduction is turned on if the exposure is 1 second or longer and noise common to long exposures is detected.

2. <On>: Noise reduction is turned on for all exposures.

C.Fn-3 Flash sync speed in Av mode

This setting controls the camera-selected flash-sync speed in Av mode.

0. <Auto>: the camera varies the shutter speed to match the ambient light conditions.

1. <1/200sec. (fixed)>: the camera always uses 1/200 sec. in Av mode. This Custom Function doesn't seem to be particularly useful, since using Manual Exposure (M) mode at 1/200 then changing f/stop would give you the same feature without going through the menu.

C.Fn-4 Shutter button/AE lock button

This controls the functions of the shutter and AE lock buttons. The best way to read this setting is to pay attention to the "/".

0. <AF/AE lock>: Autofocus is initiated when the shutter button is depressed halfway. Exposure is locked with the AE lock button ✱ .

1. <AE lock/AF>: Autofocus is initiated with the ✱ . The shutter button locks exposure when depressed halfway.

2. <AF/AF iock, no AE lock>: Pressing the ✱ temporarily interrupts and locks focus in AI Servo AF mode. The exposure is set when the shutter releases, preventing focus from being thrown off if an object passes briefly in front of the camera.

3. <AE/AF, no AE lock>: Lets you start and stop AI Servo AF by pushing the ✱ . Exposure is set when the shutter releases.

C.Fn-5 AF-assist beam

This controls the AF-assist beam, which is useful when using autofocus in low-light situations.

0. <Emits>: The AF-assist beam is emitted whenever appropriate.

1. <Does not emit>: This cancels the AF-assist beam.

2. <Only external flash emits>: In low light, an accessory EX flash unit will fire its AF assist beam. The built-in flash's AF assist feature is disabled.

C.Fn-6 Exposure level increments

This sets the size of incremental steps for shutter speeds, apertures, exposure compensation, and autoexposure bracketing (AEB).

0. <1/3 stop>: the increment is 1/3 stop

1. <1/2 stop>

C.Fn-7 Mirror lockup

This Custom Function turns Mirror lockup on or off. Mirror lockup is used to minimize camera shake during exposures.

0. <Disable>: The mirror functions normally.

1. <Enable>: The mirror will move up and lock in position with the first push of the shutter button (press fully). With the second full pressing of the shutter button, the camera will take the picture and the mirror will return to its original position. After 30 seconds, this setting automatically cancels.

C.Fn-8 E-TTL II

This is a simple control that lets you choose a different way of metering electronic flash.

0. <Evaluative>: This uses fully automatic Evaluative metering for all conditions.

1. <Average>: This setting averages the flash exposure readings over the entire area covered by the flash. Flash exposure compensation will not work with this setting.

The Custom Functions available on the Rebel XTi allow you to choose what settings are most valuable to you, and manage those to complement your shooting style.

C.Fn-9 Shutter curtain sync

This is a creative control that determines how motion blurs are rendered in flash photography.

0. <1st-curtain sync> (also called front-curtain sync): This is the standard flash sync for most cameras, including the Rebel XTi. The flash goes off at the beginning of the exposure, as soon as the shutter curtains fully open to expose the whole sensor. At slow shutter speeds, the flash will create a sharp image and motion blur is registered after the flash. With moving subjects, this results in a blur or light trail that appears to be in front of the sharp flash-exposed subject (because the movement forward is after the flash). Such a blur is not natural looking.

1. <2nd-curtain sync> (also called rear-curtain sync): The flash fires at the end of the exposure, just before

the second shutter curtain closes. At slow shutter speeds, this results in an ambient light motion blur that looks natural because it trails behind a moving, sharp flash-exposed subject.

C.Fn-10 Magnified view

This control offers the option of magnifying an image immediately after shooting instead of just during playback.

0. <Image playback only>: Image can be magnified on the LCD only during playback (see page 88).

1. <Image review and playback>: Image can be magnified during review (immediately after shooting) by holding down the 🗑∿ and pressing 🖸 ⊕. Magnification during playback is engaged the normal way.

C.Fn-11 LCD display when power on

This function keeps track of whether the LCD monitor has been turned off to save power.

0. <Display>: LCD displays camera settings when the Power switch is turned on.

1. <Retain power OFF status>: When the Power switch is turned on the LCD display will stay off if you have used **DISP.** to turn the LCD off.

Note: At the bottom of the Custom Functions menu is a row of digits showing the current settings for each of the Custom Functions.

Camera Operation Modes

The Rebel XTi is a highly sophisticated and, in many ways, amazing digital camera. The innovation, thought, and technology that have gone into this camera become evident as soon as you begin to operate its various systems and utilize its many functions. From finding focus on moving subjects, to shooting multiple frames per second, to capturing great exposures in low light, the Rebel XTi offers a number of options to help you take extraordinary photographs.

Focus

The Rebel XTi uses an AI Focus AF (artificial intelligence autofocus) system based on a special CMOS sensor dedicated to autofocus. The nine AF points give the camera nine distinct spots where it can measure focus. They are arranged in a diamond pattern. The diagonal arrangement of autofocus points around the center make for improved focus tracking of moving subjects.

The AF points work with an EV (exposure value) range of EV -0.5-18 (at ISO 100), and are superimposed in the viewfinder. They can be used automatically (the camera selects them as needed), or you can choose one manually. AF modes are selected by the photographer and include One-Shot AF, AI Focus AF, and AI Servo AF. Manual focusing is also an option.

The Rebel XTi's autofocusing technology gives you the ability to quickly and consistently shoot sharp, clear images of almost any subject matter.

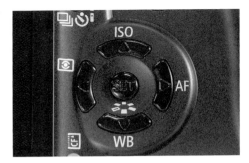

The Rebel XTi smartly handles various functions of autofocus through the use of a high-performance, 32-bit RISC microcomputer along with improvements in AF system design. The camera's ability to autofocus while tracking a moving subject is quite good. According to Canon, for example, in AI Servo AF (continuous focus) with an EF 300mm f/2.8 IS USM lens, the Rebel XTi can focus-track a subject moving toward the camera at a speed of 31mph (50kph) up to about 32.8 feet (10 meters) away. It has the ability to very quickly employ statistical prediction while using multiple focusing operations to follow even an erratically moving subject. And yet, if the subject is not moving, the AI Servo AF focus control is notably stable—it will not allow the lens to change focus at all until the subject moves again.

When light levels are low, the camera activates AF-assist with the built-in flash and produces a series of quick flashes to help autofocus. (External dedicated flashes will also do this.) The range is to approximately 13.1 feet (4 meters) in the center of the frame and 11.5 feet (3.5 meters) at the other AF points. The 580EX Speedlite includes a more powerful AF-assist beam effective up to 33 feet (10.1 meters).

AF Modes

The camera has three AF modes, in addition to manual focus: One-Shot AF (AF stops and locks when focus is achieved, one shot at a time), AI Servo AF (this tracks subject

movement and focuses continuously until the exposure is made) and AI Focus AF (the camera switches automatically between One-Shot AF and AI Servo AF as it detects movement at the subject's position).

In the Basic Zones, the AF mode is set automatically. In the Creative Zone, you can choose among all three settings. They are accessed by pressing the AF Right Cross Key ▶ AF . The AF mode menu will display on the LCD monitor. Use the Cross Keys ✧ or Main dial 🕭 to select the mode you want. Once selected, press SET (SET) or the shutter. The selected AF mode will be indicated on the camera settings display on the LCD monitor.

Each is used for different purposes:

<One-Shot AF>: This AF mode finds and locks focus when you press the shutter button halfway. Perfect for stationary subjects, it allows you to find and hold focus at the important part of a subject. If the camera doesn't hit the right spot, simply change the framing slightly and repress the shutter button halfway to lock focus. Once you have found focus and locked, you can then move the camera to set the proper composition. The focus confirmation light will glow steadily in the viewfinder when you have locked focus. It will blink when the camera can't achieve focus. Since this camera focuses very quickly, a blinking light is a quick reminder that you need to change something (you may need to focus manually).

<AI Servo AF>: Great for action photography where subjects are in motion, AI Servo AF becomes active when you press the shutter button down halfway, but it does not lock focus. It continually looks for the best focus as you move the camera or the subject travels through the frame. It is really designed for moving subjects, as both the focus and exposure are set only at the moment of exposure. This can be a problem when used for motionless subjects because the focus will continually change, especially if you are hand-holding the camera. However, if you use AI Servo AF on a moving subject, it is a good idea to start the camera focusing

(depressing the shutter halfway) before you actually need to take the shot so the system can find the subject.

<AI Focus AF>: This mode allows the camera to choose between One-Shot and AI Servo. It can be used as the standard setting for the camera because it switches automatically from One-Shot to AI Servo if your subject should start to move. Note, however, that if the subject is still (like a landscape), this mode might detect other movement (such as a blowing tree), so it may not lock on the non-moving subject.

<Selecting an AF Point>: You can have the camera select the AF point automatically, or you can use either the Cross Keys ✛ or the Main dial 🔄 to manually select a desired point. Manual AF point selection is useful when you have a specific composition in mind and the camera won't focus consistently where you want. To use the Cross Keys ✛ to manually select an AF point, simply push the AF point selection button ⊞ ⊕ (on the upper right corner of the camera's back), and use the Cross Keys ✛ to select the AF point. Points light up in the viewfinder as they are selected. If all points are lit, the camera will automatically make the selection. You can press the ⑤ⓔⓣ button to toggle between the center AF point and automatic selection. This is an intuitive control that is simple to use.

You can also use the Main dial 🔄 instead of the Cross Keys ✛ . This method will rotate through all of the points and is not as direct as selecting points with the ✛ . However, some photographers find the dial is easier to put their finger on while looking through the viewfinder.

At any time during AF point selection you can return to shooting mode by either pressing the shutter half way or pressing the AF mode selection button ▶ AF . You do not need to press the ⑤ⓔⓣ button to have the camera accept your selection.

<AF Limitations>: AF sensitivity is high with this camera. The Rebel XTi can autofocus in conditions that are quite challenging for other cameras. Still, as the maximum aperture of

lenses decrease, or tele-extenders are used, the camera's AF capabilities will change, working best with f/2.8 and wider lenses. This is normal and not a problem with the camera.

It is possible for AF to fail in certain situations, requiring you to focus manually. This is most common when the scene is low-contrast or has a continuous tone (such as sky), in conditions of extremely low light, with subjects that are strongly backlit, and with compositions that contain repetitive patterns. A quick way to deal with these situations is to focus on something else at the same distance, lock focus on it (by keeping the shutter pressed halfway), then move the framing back to the original composition. This only works while the camera is in One-Shot AF mode.

Drive Modes and the Self-Timer

The Rebel XTi offers two shooting speeds—Single shooting drive mode ☐ (one image at a time) or Continuous shooting drive mode ☐」 (up to 3 fps). There is also an option for a 10-second Self-timer ☉ᵢ . Drive modes are selected by pressing the Drive mode selection button ☐」☉ᵢ on the back of the camera to the right of the LCD monitor.

Once pressed, the Drive mode menu will display on the LCD monitor. Use the Left/Right Cross Keys ◄► or Main dial ⌒ to select the mode you want, then press SET (SET) or the shutter. The selected drive mode will be indicated on the camera settings display on the LCD monitor.

The Self-timer is set for ten seconds and can be used in any situation where you need a delay between the time you press the shutter button and when the camera actually fires. It can even be helpful when you are shooting slow shutter speeds on a tripod and can't (or don't want to) use a cable release. The 10-second delay allows camera vibrations to settle down before the shutter goes off. (In cases where you are using the Self-timer and Mirror lockup, the Self-timer will use a two-second delay.)

Exposure

No matter what technology is used to create a photo, it is always preferable to have the best possible exposure. Digital photography is no exception. A properly exposed digital file is one in which the right amount of light has reached the camera's sensor and produces an image that corresponds to the scene, or to the photographer's interpretation of the scene. This applies to color reproduction, as well as tonal values and subject contrast.

ISO

The first step in getting the best exposure with film cameras was setting the ISO film speed. This provided the meter with information on the film's sensitivity to light, so that it could determine how much exposure would be required to record the image. Digital cameras adjust the sensitivity of the sensor circuits to settings that can be compared to film of the same ISO speed. (This change in sensitivity involves amplifying the electronic sensor data that creates the image.)

The Rebel XTi offers ISO sensitivity settings of 100-1600. This full ISO range is only available in the Creative Zone exposure modes (see pages 117-124). In the Basic Zone modes (see pages 114-116), ISO is set automatically from 100-400 and you cannot override it.

ISO is one control worth knowing so well that its use becomes intuitive. Its speed can be set quickly in the Creative Zone. Since sensitivity to light is easily adjustable using a digital SLR, and since the Rebel XTi offers clean images with minimal to no noise at any standard setting, ISO is a control to use freely so you can adapt rapidly to changing light conditions.

Low ISO settings give the least amount of noise and the best color. Traditionally, film would increase in grain and decrease in sharpness with increased ISO. This is not entirely true with the Rebel XTi because its image is extremely clean. Some increase in noise (the digital equivalent of grain) will be

Fast moving subjects, such as horses on a race track, require higher ISO speeds (ISO 400, 800, and 1600). This allows you to use faster shutter speeds to capture sharp images.

noticed as the higher ISO settings are used, but it is minimal until the highest settings of 800 and 1600 are chosen. Little change in sharpness will be seen. Even the settings of 800 and 1600 offer very good results. This opens your digital photography to new possibilities for using slow lenses (lenses with smaller maximum lens openings, which are usually physically smaller as well) and in shooting with natural light.

Setting the ISO: To set the ISO speed, use the ISO/Up Cross Key ▲ISO. The ISO speed menu will display on the LCD monitor. Use the Up/Down Cross Keys ▲▼ or Main dial to select the mode you want. Once selected, press SET ⑤ or the shutter. The selected ISO setting will be indicated on the camera settings display on the LCD monitor.

The ISO settings occur in 1-stop increments (100, 200, 400, 800, and 1600). Most of the time you will want to choose among several key ISO settings: 100 to capture detail in images of nature, landscape, and architecture; 400 when more speed is needed, such as handholding for portraits when shooting with a long lens; 800 and 1600 when you really need a lot of speed under low-light conditions.

Metering

In order to produce the proper exposure, the camera's metering system has to evaluate the light. However, even today there is no light meter that will produce a perfect exposure in every situation. Because different details of the subject reflect light in different amounts, the Rebel XTi's metering system has been designed with microprocessors and special sensors that give the system optimum flexibility and accuracy in determining exposure.

The camera offers three user-selectable methods of measuring light: Evaluative ⊙ (linked to any desired AF point), Partial ⊡ , and Center-Weighted Average ☐ . The metering modes are selected by pressing the Left Cross Key ◄⊡ . The Metering mode menu will display on the LCD monitor. Use the Left/Right Cross Keys ◄► or ⚙ to select the mode you want. Once selected, press ⑤ or the shutter. The symbol or icon for the type of metering in use will be indicated on the camera settings display on the LCD monitor.

⊙ **Evaluative Metering:** The Rebel XTi's Evaluative metering system divides the image area into 35 zones, "intelligently" compares them, and then uses advanced algorithms to determine exposure. Basically, the system evaluates and compares all of the metering zones across the image, noting things like the subject's position in the viewfinder (based on focus points and contrast), brightness of the subject compared to the rest of the image, backlighting, and much more. These zones come from a grid of carefully designed metering areas that cover the frame, though there are fewer at the edges.

As with all Canon EOS cameras, the Rebel XTi's Evaluative metering system is linked to Autofocus. The camera actually notes which autofocus point is active and emphasizes the corresponding metering zones in its evaluation of the overall exposure. If the system detects a significant difference between the main point of focus and the different areas that surround this point, the camera automatically applies exposure compensation. (It assumes the scene includes a backlit or spot-lit subject.) However, if the area around the focus point is very bright or dark, the metering can be thrown off and the camera may underexpose or overexpose the image. When your lens is set to manual focus, Evaluative metering will use the center autofocus point.

Note: With Evaluative metering, after Autofocus has been achieved, exposure values are locked as long as the shutter button is partially depressed. However, meter readings cannot be locked in this manner if the lens is set for manual focus. You must use the AE lock button ✳ in that case.

It is difficult to capture perfect exposures when shooting extremely dark or light subjects, subjects with unusual reflectance, or backlit subjects. Because the meter theoretically bases its analysis of light on an average gray scene, when subjects or the scene differ greatly from average gray, the meter will tend to overexpose or underexpose them. Luckily, you can check exposure information in the viewfinder, or check the image itself on the LCD monitor, and make adjustments as needed.

The main advantage of Evaluative metering over Partial and Center-Weighted Average metering is that the exposure is biased toward the active AF point, rather than just concentrating on the center of the picture. Plus, Evaluative metering is the only metering mode that will automatically apply exposure compensation based on comparative analysis of the scene.

▣ **Partial Metering:** Partial metering covers about 9% of the frame, utilizing the exposure zones at the center of the viewfinder. This allows the photographer to selectively meter portions of a scene and compare the readings in order to select the right overall exposure. This can be an extremely accurate way of metering, but it requires some experience to do well. When shooting with a telephoto lens, Partial metering acts like Spot metering.

☐ **Center-Weighted Average Metering:** This method averages the reading taken across the entire scene. In computing the "average exposure", however, the camera puts extra emphasis on the reading taken from the center of the horizontal frame. Since most early traditional SLR cameras used this method exclusively, some photographers have used Center-Weighted Average metering for such a long time that it is second nature and they prefer sticking with it. It can be very useful with scenes that change quickly around the subject.

One area in which to be careful with regard to exposure and this camera is the viewfinder eyepiece. This may sound odd, yet if you are shooting a long exposure on a tripod and do not have your eye to the eyepiece, there is a good possibility that your photo will be underexposed. The Rebel XTi's metering system is sensitive to light coming through an open eyepiece. To prevent this, Canon has included an eyepiece cover on the camera strap that can be slipped over the viewfinder to block the opening in these conditions. You can quickly check the effect by watching the camera settings on the LCD monitor as you cover and uncover the eyepiece—you'll see how much the exposure can change. You'll need to turn on the <auto-off function> of the LCD monitor using Custom Functions (see page 94) to see the display while covering the eyepiece.

Judging Exposure

The LCD monitor allows you to get an idea of your photo's exposure—it's sort of like using a Polaroid, although not as accurate. With a little practice, however, you can use this small image to evaluate your desired exposure. Recognize

that because of the monitor's calibration, size, and resolution, it only gives an indication of what you will actually see when the images are downloaded into your computer.

The Rebel XTi includes two features—Highlight alert and the histogram— that give you a good indication of whether or not each exposure is correct. These features can be seen on the LCD monitor once an image is displayed there. Push the **DISP.** button repeatedly to cycle through a series of three displays: one shows the image along with exposure information, another is a small photo showing Highlight alert, the histogram and exposure information, and the third shows the photo only (no information displayed).

Highlight Alert: The camera's Highlight alert is very straightforward: overexposed highlight areas will blink on the small photo displayed next to the histogram. These areas have so much exposure that only white is recorded, no detail. It is helpful to immediately see what highlights are getting blown out, but some photographers find the blinking a distraction. Blinking highlights are simply information, and not necessarily bad. Some scenes have less important areas that will get washed out when the most important parts of the scene are exposed correctly. However, if you discover that significant parts of your subject are blinking, the image is likely overexposed. You need to reduce exposure in some way.

The Histogram: The Rebel XTi's histogram, though small, is an extremely important tool for the digital photographer. It is the graph that appears on the LCD monitor next to the image when selected with **DISP.** during review or playback. There are two different kinds of histograms that the XTi can display: Brightness and RGB. The Brightness histogram allows you to judge the overall exposure of the image, while the RGB histogram focuses in on the individual color channels.

The horizontal axis of the histogram represents the level of brightness—dark areas are at the left, bright areas are at the right. The vertical axis indicates the pixel quantity existing for the different levels of brightness. If the graph rises as

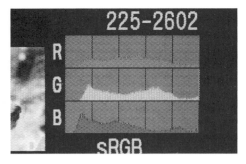

The RGB histogram on the Rebel XTi gives you an idea of how the different color channels were exposed in a specific shot.

a slope from the bottom left corner of the histogram, then descends towards the bottom right corner, all the tones of the scene are captured.

Consider the graph from left to right (dark to bright). If the graph starts too high on either end, i.e., so the "slope" looks like it is abruptly cut off at either side, then the exposure data is also cut off or "clipped" at the ends because the sensor is incapable of handling the areas darker or brighter than those points. An example would be a dark, shadowed subject on a bright, sunny day. In addition, the histogram may be weighted towards either the dark or bright side of the graph (wider, higher "hills" appear on one side or the other). This is okay if the subject is mostly dark or bright, but if it is not, detail may be lost. The dark sections of your photo may fade to black (with increased noise), and brighter sections may appear completely washed out.

If highlights are important, be sure that the slope on the right reaches the bottom of the graph before it hits the right side. If darker areas are important, be sure the slope on the left reaches the bottom before it hits the left side. You really don't have to remember which side is dark or light at first. If you notice an unbalanced graph, just give the scene a change of exposure and notice which way the histogram changes. This is a really good way to learn to read the histogram.

Some scenes are naturally dark or light. In these cases, most of the graph can be on the left or right, respectively. However,

Check the Brightness histogram on your LCD monitor to ensure you have captured adequate detail in the dark and light areas of a image.

be careful of dark scenes that have all the data in the left half of the histogram. Such underexposure tends to overemphasize any sensor noise that might be present. You are better off increasing the exposure, even if the LCD image looks bright enough. You can always darken the image in the computer, which will not affect grain; yet lightening a very dark image usually will have an adverse effect and result in added noise.

If the scene is low in contrast and the histogram is a rather narrow hill in the middle of the graph, check the Rebel XTi's Picture style. Boosting contrast will expand the histogram—you can create a custom setting with contrast change and tonal curve adjustments that will consistently address such a situation. This can mean better information being captured—it is spread out more evenly across the tones—before bringing the image into your computer to use image-processing

software. In addition, this type of histogram is a good indicator of when to shoot using RAW, because results are best in RAW when the data has been stretched to make better use of the tonal range from black to white.

With the RGB histogram, you are able to check to see if any of the individual color channels are over-saturated. Similar to the Brightness histogram, the horizontal scale represents each color channel's brightness level—if more pixels are to the left, the color is less prominent and darker; to the right, the color is brighter and denser. If the histogram shows an abrupt cut-off on either end of the histogram, your color information will either be missing or over-saturated. In short, by checking the RGB histogram, you are evaluating the color saturation and white balance bias.

Choose between Brightness and RGB histogram displays by accessing the Playback menu ▶ , using the Up/Down Cross Keys ▲▼ (or 🔆) to select <Histogram>, pressing ⓢ , and choosing between <Brightness> and <RGB>. Press ⓢ again to accept the selections.

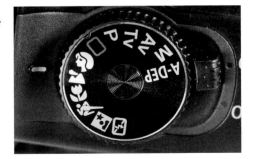

The Mode dial allows you to choose a preset shooting mode (Basic Zone) or use a more flexible mode (Creative Zone), depending on the situation and your comfort level.

Basic Zone Shooting Modes

The Rebel XTi offers twelve exposure, or shooting, modes divided into two groups: the Basic Zone and the Creative Zone. In the Basic Zone, the primary benefit is that the camera can be matched quickly to conditions or to a subject. Fast and easy to manage, the modes in the Basic Zone permit the camera to predetermine a number of settings.

Exposure, ISO, and white balance are set automatically in all Basic Zone modes, while the metering method is Evaluative. In some of these modes, all the controls are set by the camera and cannot be adjusted by the photographer.

All exposure modes, including the Basic Zone modes, are selected by using the Mode dial on the top right of the camera. Simply rotate the dial to the icon you wish to use. Basic Zone modes are identified by a picture icon; Creative Zone modes are selected with the letter icons.

Note: When you are in any of the Basic Zone modes, the Shooting 2 menu 📷2 and several items in the Shooting 1 📷1 and Set-up 2 🔧2 menus are not accessible. Also, all Basic Zones use JPEG with fine compression and sRGB colorspace, Auto White balance, Auto ISO, and Evaluative metering.

▢ **Full Auto:** The green rectangle selects Full Auto ▢ , which is used for completely automatic shooting. This mode essentially converts the Rebel XTi into a point-and-shoot camera—a very sophisticated point-and-shoot! The camera chooses everything; you cannot adjust any controls. This mode is really designed for the beginning photographer who does not trust his or her decisions or for situations when you hand the camera to someone to take a picture of you. That way they can't mess up settings. The Picture Style is Standard, for crisp, vivid images; the drive is set for Single shooting; and focus method is set for AI Focus. The flash will fire if needed.

❧ **Portrait:** If you like to shoot portraits, this setting makes adjustment choices that favor people photography. The drive is set to Continuous so you can quickly shoot changing gestures and expressions, while the AF mode is set to One-Shot so you can lock focus with a slight pressing of the shutter release. The meter favors wider f/stops (those with smaller numbers) because this limits depth of field, offering backgrounds that are softer and therefore contrast with the sharper focus of the subject. A wider f/stop also results in faster shutter speeds,

producing sharper handheld images. Picture style is set to Portrait for softer skin tones (see page 60).

Landscape: When doing landscape photography, it is important to lock focus on one shot at a time, so Landscape mode uses One-Shot AF and the Single shooting drive mode. The meter favors small f/stops for more depth-of-field (often important for scenic shots). Picture style is set to Landscape for vivid greens and blues. The flash will not fire.

Close-Up: This mode also uses One-Shot AF and the Single shooting modes. It favors wider f/stops for faster shutter speeds, giving better sharpness with a handheld camera and far less depth of field (to set off a sharp subject against a softer background). Picture style is set to Standard. The flash will fire if needed.

Sports: Designed for action and fast shutter speeds to stop that action, Sports mode uses AI Servo AF and the Continuous shooting drive mode, both of which allow continuous shooting as action evolves in front of you. In addition, the beep for AF confirmation will be softer than other modes. Picture style is set to Standard. The flash will not fire.

Night Portrait: Despite its name, this setting is not limited to nighttime use. It is very useful for even advanced photographers to balance flash with low light conditions. This setting uses flash to illuminate the subject (which may or may not be a portrait), as well as an exposure to balance the background, bringing in the subject's detail. The latter exposure, called the ambient light exposure, can have a very slow shutter speed and may result in a blurry background, so you may need a tripod if that is not the effect you are going for. The Picture style is set to Standard.

Flash Off: Provides a quick and easy setting that prevents the flash from firing. This can be important in museums and other sensitive locations. The Picture style is set to Standard.

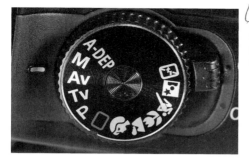

The Creative Zone exposure modes allow the photographer greater control over exposure variables.

Creative Zone Shooting Modes

The Creative Zone modes offer complete control over camera adjustments and thus encourage a more creative approach to photography. The disadvantage is that there are many possible adjustments, which can be confusing at worst, and time consuming at best. Again, all modes in the Creative Zone are engaged by turning the Mode dial to the desired designation, one of the letter icons. Adjustments to the settings, which are displayed on the LCD monitor and viewfinder, are made by turning the Main dial.

Remember that Creative Zone settings like white balance, file type (RAW or JPEG), metering method, focus method, Picture styles, ISO, and drive will need to be manually set.

P Program AE Mode: In Program AE **P** (autoexposure) mode, the camera chooses the shutter speed and aperture combination. This gives the photographer less direct control over the exposure because no matter how apt, the settings are chosen arbitrarily (by the camera, not by you). However, you can "shift" the program by changing either the selected aperture or shutter speed, and the system will compensate to maintain the same exposure value. To shift the program, simply press the shutter button halfway, then turn the Main dial until the desired shutter speed or aperture value (respectively) is displayed on the LCD monitor or viewfinder. This only works for one exposure at a time, making it useful for quick-and-easy shooting while retaining some control over camera settings. Program shift does not work with flash.

Program AE mode **P** selects shutter speed and aperture values "steplessly". This means that any shutter speed or aperture within the range of the camera and lens will be selected, not just those that are the standard full steps, such as 1/250 second or f/16. This has been common with most SLRs (both film and digital) for many years, and allows for extremely precise exposure accuracy, thanks to the lens' electromagnetically controlled diaphragm and the camera's electronically timed shutter.

Tv Shutter-Priority AE Mode: Tv (which stands for "time value") signifies Shutter-Priority AE mode. Shutter-Priority means that you set the shutter speed (using the Main dial 🗘) and the camera sets the aperture. If you want a particular shutter speed for artistic reasons—perhaps a high speed to stop action or a slow speed for a blur effect—this is the setting to use. In this mode, even if the light varies, the shutter speed will not. The camera will keep up with changing light by adjusting the aperture automatically. If the aperture indicated in the viewfinder or the LCD monitor is consistently lit (not blinking), Evaluative metering has picked a useable aperture. If the maximum aperture (lowest number) blinks, it means the photo will be underexposed. Select a slower shutter speed by turning the 🗘 until the aperture indicator stops blinking. You can also remedy this by increasing the ISO setting. If the minimum aperture (highest number) is blinking, this indicates overexposure. In this case, you should set a faster shutter speed until the blinking stops, or choose a lower ISO setting.

The Rebel XTi offers a choice of speeds, from 1/4000 second up to 30 seconds in 1/3-stop increments (1/2 stop increments with Custom Function 6; see page 97), plus Bulb setting. For flash exposures, the camera will sync at 1/200 second or slower (which is important to know since slower shutter speeds can be used to pick up ambient or existing light in a dimly-lit scene).

Let's examine these shutter speeds by designating them "fast", "moderate", and "slow". (These divisions are

118

arbitrarily chosen, so speeds at either end of a division can really be designated into the groups on either side of it.)

Fast shutter speeds are 1/500-1/4000 second. It wasn't all that long ago that most film cameras could only reach 1/1000 second, so having this range of high speeds on a digital SLR is quite remarkable. The obvious reason to choose these speeds is to stop action. The more the action increases in pace, or the closer it crosses directly in front of you, the higher the speed you will need. As mentioned previously, the neat thing about a digital camera is that you can check your results immediately on the LCD monitor to see if the shutter speed has, in fact, frozen the action.

At these fast speeds, camera movement during exposure is rarely significant unless you try to handhold a super telephoto lens of 600mm (not recommended!). This means with proper handholding technique, you can shoot using most normal focal lengths (from wide-angle to telephoto up to about 300mm) with few problems from camera movement.

Besides stopping action, another important use of the high shutter speeds is to allow you to use your lens at its wide openings (such as f/2.8 or f/4) for selective focus effects (shallow depth of field). In bright sun, for example, you might have an exposure of 1/200 second at f/16 with an ISO setting of 200. You can get to f/2.8 by increasing your speed by five whole steps of exposure, to approximately 1/4000 second.

Moderate shutter speeds (1/60-1/250 second) work for most subjects and allow a reasonable range of f/stops to be used. They are the real workhorse shutter speeds, as long as there's no fast action. You have to be careful when handholding cameras at the lower end of this range—especially with telephoto lenses—or you may notice blur in your pictures from camera movement during the exposure. Many photographers find that they cannot handhold a camera with moderate focal lengths (50-150mm) at shutter speeds less than 1/125 second without some degradation of the image due to camera movement. You can double-check

your technique by taking a photograph of a scene while handholding the camera and then comparing the same scene shot using a tripod.

Slow shutter speeds (1/60 second or slower) require something to stabilize the camera. Some photographers may discover they can handhold a camera and shoot relatively sharp images at the high end of this range, but most cannot get optimal sharpness from their lenses at these speeds without a tripod or other stabilizing mount. Slow shutter speeds are used mainly for low light conditions and to allow the use of smaller f/stops (higher f/numbers) under all conditions.

A fun use of very slow shutter speeds (1/8-1/2 second) is to photograph movement, such as a waterfall or runners, or to move the camera during exposure, such as panning it across a scene. The effects are quite unpredictable, but again, image review using the LCD monitor helps. You can try different shutter speeds and see what they look like. This is helpful when trying to choose a slow speed appropriate for the subject because each speed will blur action differently.

You can set slow shutter speeds (up to 30 seconds) for special purposes, such as capturing fireworks or moonlit landscapes. Canon has engineered the sensor and its accompanying circuits to minimize noise (a common problem of long exposures with digital cameras) and the Rebel XTi offers remarkable results with these exposures.

In contrast to long film exposures, long digital exposures are not susceptible to reciprocity. The reciprocity effect comes with film because as exposures lengthen beyond approximately one second (depending on the film), the sensitivity of the film declines, resulting in the need to increase exposure to compensate. A metered 30-second film exposure might actually require double or triple that time to achieve the effect that is desired. Digital cameras do not have this problem. A metered exposure of 30 seconds is all that is actually needed.

only in manual (M)

The setting for Bulb Exposure allows you to control long exposures (<bulb> follows <30 seconds> when scrolling through shutter speeds). With this option, the shutter stays open as long as you keep the shutter button depressed. Let go, and the shutter closes. A dedicated remote switch, such as the Canon RS-60E3, is very helpful for these long exposures. It allows you to keep the shutter open without touching the camera (which can cause movement). It attaches to the camera's remote terminal (on the left side). You can use the infrared RC-1 wireless remote switch for bulb exposures, as well.

The camera will show the elapsed time (in seconds) for your exposure as long as you keep the remote switch depressed. This can be quite helpful in knowing your exposure. At this point in digital camera technology, exposures beyond a few minutes start to have serious problems. Still, the Rebel XTi allows longer exposures than most cameras of this type. It is a good idea to use the noise reduction selection in the Custom Functions menu to apply added in-camera noise reduction (see page 96). Remember that long exposure noise reduction doubles the apparent exposure time so make sure you have enough battery power.

Av Aperture-Priority AE Mode: When you select **Av** (aperture value), you are in Aperture-Priority AE mode. In this autoexposure mode, you set the aperture (the f/stop or lens opening) and the camera selects the appropriate shutter speed for a proper exposure. This is probably the most popular automatic exposure setting among professional photographers.

Controlling depth of field is one of the most common reasons for using Aperture-Priority mode. (Depth of field is the distance in front of and behind a specific plane of focus that is acceptably sharp.) While the f/stop, or aperture, affects the amount of light entering the camera, it also has a direct effect on depth of field. A small lens opening (higher f/number) such as f/11 or f/16 will increase the depth of field in the photograph, bringing objects in the distance into sharper focus when the lens is focused appropriately. Higher f/numbers are great for landscape photography.

A wide lens opening with low f/numbers such as f/2.8 or f/4 will decrease the depth of field. These lower f/numbers work well when you want to take a photo of a sharp subject that creates a contrast with a soft, out-of-focus background. If the shutter speed is blinking in the viewfinder (or on the LCD monitor), it means good exposure is not possible at that aperture, so determine whether you need to change the aperture or ISO setting.

You can see the effect of the aperture setting on the image by pushing the Depth-of-field preview button on the camera (located on the lower left of the front lens housing, below the lens release button). This stops the lens down to the taking aperture and reveals sharpness in the resulting darkened viewfinder (the lens otherwise remains wide-open until the next picture is taken). Using Depth-of-field preview takes some practice because of how much the viewfinder darkens, but changes in focus can be seen if you look hard enough. You can also check focus in the LCD monitor after the shot (magnify as needed), since digital allows you to both review and/or delete your photos as you go.

A sports or wildlife photographer might choose **Av** mode in order to stop action rather than to capture depth of field. To accomplish this, he or she selects a wide lens opening—perhaps f/2.8 or f/4—to let in the maximum amount of light. In **Av** mode, the camera will automatically select the fastest shutter speed possible for the conditions. Compare this with **Tv** mode. There you can set a fast shutter speed, but the camera still may not be able to expose correctly if the light drops and the selected shutter speed requires an opening larger than the particular lens can provide. (The aperture value will blink in the viewfinder if this is the case.) As a result, photographers typically select **Tv** only when they have to use a specific shutter speed. Otherwise they use **Av** for both depth of field and to gain the highest possible shutter speed for the circumstances.

A·DEP Automatic Depth-of-Field AE: This is a unique exposure mode that Canon has used on a number of EOS SLRs

(both film and digital) over the years. **A-DEP** simplifies the selection of an f/stop to ensure maximum depth of field for a subject. The camera actually checks focus, comparing all seven AF points to determine the closest and farthest points in the scene. The camera then picks an aperture to cover that distance and the appropriate shutter speed. You cannot control either yourself. It also sets the focus distance. If the camera cannot get an aperture to match the depth of field needed to cover the near and far points, the aperture will blink. You can check what the depth of field looks like by pushing in the Depth-of-field preview button. You have to use AF (autofocus) on the lens; MF (Manual Focus) will make the camera act like **P** was set. **A-DEP** does not work with flash. If you turn on the flash the camera will also act like **P** was set.

M **Manual Exposure Mode:** Not an auto mode, the Manual Exposure mode **M** option is important both for photographers who are used to working in full manual and for anyone who faces certain tricky situations. (However, since this camera is designed to give exceptional autoexposures, I would suggest that everyone at least try the automatic settings at times to see what they can do). In **M** , you set both the shutter speed (using the Main dial ⌂) and aperture (hold down the Aperture/Exposure Compensation button Av⊠ , then turn the ⌂). You can use the exposure metering systems of the camera to guide you through manual exposure settings. The current exposure is visible on the scale at the bottom of the viewfinder information display. "Correct" exposure is at the mid-point, and you can see how much the exposure settings vary from that point by observing the scale. The scale shows up to two f/stops over or under the mid-point, allowing you to quickly compensate for bright or dark subjects (especially when using Partial metering). If the pointer on the scale blinks, the exposure is off the scale. Of course, you can also use a hand-held meter.

The following examples of complex metering conditions might require you to use **M** mode: panoramic shooting (you need a consistent exposure across the multiple shots

taken, and the only way to ensure that is with **M** —white balance should be custom also, or at least not 🆚); lighting conditions that change rapidly around a subject with consistent light (a theatrical stage, for example); close-up photography where the subject is in one light but slight movement of the camera dramatically changes the light behind it; and any conditions where you need a consistent exposure through varied lighting conditions.

✳ AE Lock

AE lock ✳ is a very useful tool in the autoexposure modes. Under normal operation, the camera continually updates exposure either as you move the camera across the scene or as the subject moves. This can be a problem if the light across the area is inconsistent yet remains constant on the subject. In this case, you will want to lock the exposure on the subject. AE lock ✳ is also helpful when a scene is mostly in one light, yet your subject is in another. In that circumstance, try to find a spot nearby that has the same light as your subject, point the camera at it and lock exposure, then move the camera back to the original composition. (If you have a zoom lens mounted you could zoom in to a particular area of the scene, as well.)

AE lock on the Rebel XTi is similar to that used for most EOS cameras. The AE lock button ✳ is located on the back of the camera to the upper right.

Aim the camera where needed for the proper exposure, then push this button. The exposure is "locked" or frozen, even if you move the camera. An asterisk ✳ will appear in the viewfinder on the left of the information display until the lock is released.

Av🔲 Exposure Compensation

The existence of a feature for exposure compensation, along with the ability to review images in the LCD monitor, means you can quickly get good exposures without using **M** mode. Exposure compensation Av🔲 cannot be used in **M** mode; however, it makes the **P** , **Tv** , **Av** and

A-DEP modes much more versatile. Compensation is added (for brighter exposure) or subtracted (for darker exposure) in f/stop increments of 1/3 for up to +/- 2 stops (1/2 stop increments with Custom Function 6; see page 97).

Exposure Compensation Av☒ works quite easily with the Main dial 🗘 . Simply press the shutter button halfway to turn on the metering system, then press and hold the Aperture/Exposure Compensation button Av☒ (to the upper right of the LCD monitor). Rotate the 🗘 to change the compensation amount. You will see the exact exposure compensation on the scale at the bottom of the viewfinder information display, as well as on the LCD monitor. (You can also adjust Exposure Compensation without turning on the metering system by just viewing the camera settings on the LCD monitor while pressing Av☒ and using 🗘 .)

It is important to remember that once you set your Exposure Compensation control, it stays set even if you shut off the camera. Check your exposure setting as a regular habit (by looking at the bottom scale in the viewfinder information display) when you turn on your camera to be sure the compensation is not inadvertently set for a scene that doesn't need it.

With experience, you will find that you use Exposure Compensation routinely with certain subjects. Since the meter wants to increase exposure on dark subjects and decrease exposure on light subjects to make them closer to middle gray, Exposure Compensation may be necessary. For example, say you are photographing a high school soccer game with the sun behind the players. The camera wants to underexpose in reaction to the bright sunlight, but the shaded sides of the players' bodies may be too dark. So you add exposure with the Exposure Compensation feature. Or maybe the game is in front of densely shaded bleachers. In this case the players would be overexposed because the camera wants to react to the darkness. Here, you subtract exposure. In both cases, the camera will consistently maintain the exposure you have selected until you readjust the exposure settings.

The LCD monitor can come in handy when experimenting with Exposure Compensation. Take a test shot, and then check the photo and its histogram. If it looks good, go with it. If the scene is too bright, subtract exposure; if it's too dark, add it. Again, remember that if you want to return to making exposures without using compensation, you must move the setting back to zero!

📸 Autoexposure Bracketing

The Rebel XTi also offers another way to apply exposure compensation: by using the Autoexposure Bracketing control (AEB). AEB tells the camera to make three consecutive exposures that are different: (1) a standard exposure (it will use any setting of the Exposure Compensation function as the standard); (2) one with less exposure; and (3) one with more. The difference between exposures can be set up to +/- 2 stops in stop increments of 1/3. (Custom Function 6 will allow you to change this to 1/2 stop increments.) While using AEB, the Rebel XTi will change the shutter speed in **Tv** mode and aperture in **Av** mode.

AEB is set through the Shooting 2 menu **📷2** . Scroll to AEB with the Cross Keys ✛ , press ⑤ET , then use the Left/Right Cross Keys ◀▶ or Main dial again to set the amount. Three dots indicating the range of exposures will appear on a small exposure scale on this menu. When you press ⑤ET to accept the change, 📸 appears in the camera settings display on the LCD monitor.

Note: If Custom Function 6 is set for 1/2-stop increments, you may see more dots. This is because the exposure scale is laid out in 1/3-stop increments and sometimes 1/2-stop indicators are between the hash marks.

As you shoot, you will also see a marker appear on the exposure scale at the bottom of the viewfinder information display. This marker indicates which exposure is being used with the AEB sequence. When in Single shooting drive mode ☐ , you have to press the shutter button for each of the three shots. In Continuous shooting drive mode

⬚ , the camera will take the three shots and stop. With the Self-timer ⬚ , all three shots will be taken. If you use AEB, remember that the camera will continue to take three different exposures in a row until you reset the control to zero, turn the camera off, change lenses, or replace the CF card or battery.

AEB can help ensure that you get the best possible image files for later adjustment using image-editing software. A dark original file always has the potential for increased noise as it is adjusted, and a light image may lose important detail in the highlights. AEB can help you to determine the best exposure for the situation. You won't use it all the time, but it can be very useful when the light in the scene varies in contrast or is complex in its dark and light values.

AEB is also important for a special digital editing technique that allows you to put multiple exposures together into one master to gain more tonal range from a scene. You can take the well-exposed highlights of one exposure and combine them with the better-detailed shadows of another. (This works best with 1/2 stop bracketing.). If you carefully shot the exposures with your camera on a tripod, they will line up exactly so that when you put the images on top of one another as layers using image-editing software, the different exposures are easy to combine. (You may even want to set the camera to Continuous shooting drive ⬚ —in this mode it will take the three photos for the AEB sequence and then stop.)

You can combine Exposure Compensation with AEB to handle a variety of difficult situations. But remember, while AEB will reset when you turn off the camera, Exposure Compensation will not.

Flash

Electronic flash is not just a supplement for low light; it can also be a wonderful tool for creative photography. Flash is highly controllable, its color is precise, and the results are repeatable. However, the challenge is getting the right look. Many photographers shy away from using flash because they aren't happy with the results. This is because on-camera flash can be harsh and unflattering, and taking the flash off the camera used to be a complicated procedure with less than sure results. The Canon EOS Rebel XTi's sophisticated flash system eliminates many of these concerns and, of course, the LCD monitor gives instantaneous feedback. This alleviates the guesswork. With digital, you take a picture and you know immediately whether the lighting is right or not. You can then adjust the light level higher or lower, change the angle, soften the light, color it, and more. Just think of the possibilities:

Fill Flash—Fill in harsh shadows in all sorts of conditions and use the LCD monitor to see exactly how well the fill flash is working. Often, you'll want to dial down the output of an accessory flash to make sure the fill is natural looking.

Off-Camera Flash—Putting a flash on a dedicated flash cord will allow you to move the flash away from the camera and still have it work automatically. Using the LCD monitor, you can see exactly what the effects are so you can move the flash up or down, left or right, for the best light and shadows on your subject.

Fill flash is a wonderful tool for many types of lighting situations. You can fill in dark shadows in bright daylight conditions, or you can give a boost to existing light in darker conditions.

Close-Up Flash—This used to be a real problem, except for those willing to spend some time experimenting. Now you can see exactly what the flash is doing to the subject. This works fantastically well with off-camera flash, as you can "feather" the light (aim it so it doesn't hit the subject directly) to gain control over its strength and how it lights the area around the subject.

Multiple Flash—Modern flash systems have made exposure with multiple flashes easier and more accurate. However, since the flash units are not on continuously, they can be hard to place so that they light the subject properly. Not anymore. With the Rebel XTi, it is easy to set up the flash, and then take a test shot. Does it look good, or not? Make changes if you need to. In addition, this camera lets you use certain EX-series flash units (and independent brands with the same capabilities) that offer wireless exposure control. This is a good way to learn how to master multiple-flash setups.

Colored Light—Many flashes look better with a slight warming filter, but that is not what this tip is about. With multiple light sources, you can attach colored filters (also called gels) to the various flashes so that different colors light different parts of the photo. (This can be a very trendy look.)

Balancing Mixed Lighting—Architectural and corporate photographers have long used added light to fill in dark areas of a scene so it looks less harsh. Now you can double-check the light balance on your subject using the LCD monitor. You can even be sure the added light is the right color by attaching filters to the flash to mimic or match lights (such as a green filter to match fluorescents).

Flash Synchronization

The Rebel XTi is equipped with an electromagnetically timed, vertically traveling focal-plane shutter that forms a slit to expose the sensor as it moves across it. One characteristic of focal-plane shutters is that at shutter speeds faster than the flash sync speed, the entire surface of the sensor will not be exposed at the same time—or thus, by the flash. So, if you use flash with a shutter speed that is higher than the maximum flash sync speed, you will get a partially exposed picture. However, at shutter speeds below the maximum sync speed, the whole sensor surface will be exposed at some point to accept the flash.

The Rebel XTi's maximum flash sync speed is 1/200 second. If you use a flash and set the exposure to a speed faster than that in **Tv** or **M** mode, the camera will automatically reset the speed to 1/200. The camera also offers high-speed sync with EX-series flash units that allow flash at all shutter speeds (even 1/4000 second where, basically, the flash fires continuously as the slit goes down the sensor). High-speed synchronization must be activated on the flash unit itself and is indicated by an H symbol on the flash unit's LCD panel. See the flash manual for specific information on using high-speed flash sync.

Guide Numbers

When shopping for a flash unit, it is helpful to compare guide numbers. A guide number (GN) is a simple way to state the power of the flash unit. It is computed as the product of aperture value and subject distance and is usually included in the manufacturer's specifications for the unit. High numbers indicate more power; however, this is not a linear relationship. Guide numbers act a little like f/stops (because they are directly related to f/stops!) e.g., 56 is half the power of 80, or 110 is twice the power of 80.

The built-in flash will pop up automatically in several of the Basic Zone exposure modes when the light is low.

When using guide numbers to shop for flashes, keep the following in mind: Since distance is part of the formula, guide numbers can be expressed in feet and/or meters—so make sure you are dealing with the right measurement system. Guide numbers are usually based on ISO 100 film, but this can vary, so when comparing different units check the film speed reference. If the flash units you are comparing have zoom-head diffusers, make sure you compare the guide numbers for similar zoom-head settings.

Built-in Flash

The Rebel XTi's on-board flash pops open to a higher position than the flash on many other cameras. This reduces the chance of getting red-eye and minimizes problems with large lenses blocking the flash. The flash supports E-TTL II (an evaluative autoexposure system), covers a field of view up to a 17mm focal length and has a guide number of 43

(ISO 100, in feet) or 13 (ISO 100, in meters). Like most built-in flashes, it is not particularly high-powered, but its advantage is that it is always available and is very useful as fill-flash to modify ambient light. Unique to this flash and the Canon Speedlite 580EX, the flash sends color data to the camera's processor each time it fires. This helps the system measure many variables so that it can better maintain consistent color.

The flash pops up automatically in low light or backlit situations in the following Basic Zone exposure modes: Full Auto, Portrait, Close-Up, and Night Portrait. It will not activate in Landscape, Sports, or Flash Off modes. In the Creative Zone, you can choose to use the flash (or not) at any time. Just press the Flash button (on the upper left of the lens mount housing) and the flash will pop up. To turn it off, simply push the flash down.

In the Creative Zone, press the Flash button, located on the upper left lens mount housing, in order to raise the built-in flash at any time.

There are some variations in how the Creative Zone exposure modes work with the built-in flash. In **P** mode, the flash is fully automatic. In **Tv** , it can be used when you need a specific shutter speed. In **Av** , if you set an aperture that the flash uses for its exposure, the shutter speed will influence how much of the "ambient" light (or natural light) will appear in the image. In **M** , you set the aperture for the flash then choose a shutter speed that is appropriate for your subject. (You can use any shutter speed of 1/200 second and slower.) For more information on using flash in the Creative Zone, see pages 117-124.

Flash Metering

The Rebel XTi uses an evaluative autoexposure system, called E-TTL II, with improved flash control over earlier models. (It is based on the E-TTL II system introduced in the pro-level EOS-1D Mark II.) To understand the Rebel XTi's flash metering, you need to understand how a flash works with a digital camera on automatic. The camera will cause the flash to fire twice for the exposure. First, a preflash is fired to analyze exposure. Then the flash fires during the actual exposure, creating the image. During the preflash, the camera's Evaluative metering system measures the light reflected back from the subject. Once it senses that the light is sufficient, it cuts off the flash and takes the actual exposure with the same flash duration. The amount of flash hitting the subject is based on how long the flash is "on", so close subjects will receive shorter flash bursts than more distant subjects. This double flash system works quite well, but you may also find that it causes some subjects to react by closing their eyes during the real exposure. However, they will be well exposed!

You can lock the flash exposure when either the pop-up flash or an attached flash is turned on by pressing the FE (Flash Exposure) Lock button ✳ . (This is the same as the Exposure Lock button located on the upper right back of the camera.) The FE Lock causes the camera to emit a pre-flash so that it calculates the exposure before the shot. It also cancels the preflash that occurs immediately before the actual photograph, thereby reducing the problem with people reacting to a preflash that occurs a split-second before the actual exposure.

To use the FE Lock, turn the flash on, and then lock focus on your subject by pressing the shutter button halfway down. Next, aim the center of the viewfinder at the important part of the subject and press the FE Lock button. (⚡* will appear in the viewfinder.) Now, reframe your composition and take the picture. FE Lock produces quite accurate flash exposures.

Using the same principle, you can make the flash weaker or stronger. Instead of pointing the viewfinder at the subject to set flash exposure, point it at something light in tone or a subject closer to the camera. That will cause the flash to give less exposure. For more light, aim the camera at something black or far away. With a little experimenting, and by reviewing the LCD monitor, you can very quickly establish appropriate flash control for particular situations.

You can also use the Rebel XTi's Flash Exposure Compensation feature to adjust flash exposure by up to +/- 2 stops in 1/3-stop increments (or 1/2 stop increments if you set Custom Function 6; see page 97). It operates in similar fashion to the regular Exposure Compensation and is accessed via the Shooting 2 menu ▣2 by selecting the Flash exp comp setting. The viewfinder will display 🔳 to let you know flash exposure is being adjusted.

For the most control over flash, use the camera's **M** setting. Set an exposure that is correct overall for the scene, and then turn on the flash. (The flash exposure will still be E-TTL automatic.) The shutter speed (as long as it is 1/200 second or slower) controls the overall light from the scene (and the total exposure). The f/stop controls the exposure of the flash. So to a degree, you can make the overall scene lighter or darker by changing shutter speed, with no direct effect on the flash exposure. (Note, however, that this does not work with high-speed flash.)

Flash with Camera Exposure Modes

In the Basic Zone, you have no control over the flash. This means you have no say in when flash will be used for an exposure or how the exposure is controlled. The camera determines it all depending on how it senses the scene's light values. When the light is dim or there is a strong backlight, the built-in flash automatically pops up and fires, except in Landscape, Sports, and Flash Off modes.

In the Creative Zone, you either pop up the built-in flash by pushing the Flash button, or attach an EX Speedlite accessory flash unit and simply switch it to the ON position. The flash will then operate in the various Creative Zone modes as detailed on pages 117-124.

P Program AE

Flash photography can be used for any photo where supplementary light is needed. All you have to do is turn on the flash unit—the camera does the rest automatically. Speedlite EX flash units should be switched to E-TTL and the ready light should be on, indicating that the flash is ready to fire. While shooting, you must pay attention to the flash symbol ✦ in the viewfinder to be sure that the flash is charged when you are ready to take your picture. The Rebel XTi sets flash synchronization shutter speeds of 1/60-1/200 second automatically in **P** mode and also selects the correct aperture.

Tv Shutter-Priority AE

This mode is a good choice in situations where you want to control the shutter speed when you are also using flash. In **Tv** mode, you set the shutter speed before or after a dedicated accessory flash is turned on. All shutter speeds between 1/200 second and 30 seconds will synchronize with the flash. With E-TTL Flash in **Tv** mode, synchronization with longer shutter speeds is a creative choice that allows you to control the ambient-light background exposure. A portrait of a person at dusk that is shot with conventional TTL flash in front of a building with its lights on would illuminate the person correctly but would cause the background to go dark. However, using **Tv** mode, you can control the exposure of the background by changing the shutter speed. (A tripod is recommended to keep the camera stable during long exposures).

Av Aperture-Priority AE

Using this mode lets you balance the flash with existing light, and it allows you to control depth of field in the composition. By selecting the aperture, you are also able to influence the range of the flash. The aperture can be selected by

turning the Main dial 🔄 and watching the external flash's LCD panel until the desired range appears. The camera calculates the lighting conditions and automatically sets the correct flash shutter speed for the ambient light.

M Manual Exposure

Going Manual gives you the greatest number of choices in modifying exposure. The photographer who prefers to adjust everything manually can determine the relationship of ambient light and electronic flash by setting both the aperture and shutter speed. Any aperture on the lens and all shutter speeds between 1/200 second and 30 seconds can be used. If a shutter speed above the normal flash sync speed is set, the Rebel XTi switches automatically to 1/200 second to prevent partial exposure of the sensor.

M mode also offers a number of creative possibilities for using flash in connection with long shutter speeds. You could use zooming effects with smeared background and a sharply rendered main subject, or take photographs of objects in motion with a sharp "flash core" and indistinct outlines.

Red-Eye Reduction

In low-light conditions when the flash is close to the axis of the lens (which is typical for built-in flashes), the flash will reflect back from the retina of people's eyes (because their pupils are wide). This appears as "red-eye" in the photo. You can reduce the chances of red-eye appearing by using an off-camera flash or by having the person look at a bright light before shooting. In addition, many cameras offer a red-eye reduction feature that causes the flash to fire a burst of light before the actual exposure, resulting in contraction of the subject's pupils. Unfortunately, this may also result in less than flattering expressions from your subject.

Although the Rebel XTi's flash pops up higher than most, red eye may still be a problem. The Rebel XTi also offers a red-eye reduction feature for flash exposures, but the feature

works differently than many other cameras. The Rebel XTi uses a continuous light from a bulb next to the handgrip, just below the shutter button (you have to be careful not to block it with your fingers), that helps the subject pose with better expressions. Red-eye reduction is set in the Shooting 1 menu **◼1** under <Red-eye On/Off>.

Canon Speedlite EX Flash Units

Canon offers a range of accessory flash units in the EOS system, called Speedlites. While Canon Speedlites don't replace studio strobes, they are remarkably versatile. These highly portable flash units can be mounted in the camera's hot shoe or used off camera with a dedicated cord.

The Rebel XTi is compatible with the EX-series of Speedlites. The EX-series flash units range in power from the Speedlite 580EX, which has a maximum ISO 100 GN of 190 (feet), or 58 (meters), to the small and compact Speedlite 220EX, which has an ISO 100 GN of 72 (feet), or 22 (meters). Speedlite EX-series flash units offer a wide range of features to expand your creativity. They are designed to work with the camera's microprocessor to take advantage of E-TTL exposure control, extending the abilities of the Rebel XTi considerably.

I also strongly recommend Canon's Off-Camera Shoe Cord 2, an extension cord for your flash. When you use this cord, the flash can be moved away from the camera for more interesting light and shadow. You can aim light from the side or top of a close-up subject for variations in contrast and color. If you find that you get an overexposed subject, rather than dialing down the flash (which can be done on certain flash units), just aim the flash a little away from the subject so it doesn't get hit so directly by the light. That is often a quick fix for overexposure of close-ups.

Canon Speedlite 580EX
This top-of-the-line flash unit offers outstanding range and features adapted to digital cameras. The tilt/swivel zoom

head on the 580EX covers focal lengths from 14mm to 105mm, and it swivels a full 180 degrees in either direction. The zoom positions (which correspond to the focal lengths 24, 28, 35, 50, 70, 80, and 105mm) can be set manually or automatically. (The flash reflector zooms with the lens.) In addition, this flash "knows" what size sensor is used in each Canon digital SLR model and will vary its zoom accordingly. With the built-in retractable diffuser in place, the flash coverage is wide enough for a 14mm lens. As stated earlier, it provides a high flash output with an ISO 100 GN of 190 (feet), or 58 (meters) when the zoom head is positioned at 105mm. The guide number decreases as the angular coverage increases for shorter focal lengths, but is still quite high with a GN of 145 at 50mm or 103 at 28mm (in feet).

The large, illuminated LCD panel on the 580EX provides clear information on all settings: flash function, reflector position, working aperture, and flash range in feet or meters. The flash also includes a new Select dial for easier selection of these settings. When you press the Rebel XTi's Depth-of-field preview button (on lower left of the lens mount housing), a one-second burst of light is emitted. This modeling flash allows you to judge the effect of the flash. The 580EX also has 13 user-defined custom settings that are totally independent of the camera's Custom Functions; for more information, see the flash manual. When using multiple flashes, the 580EX can be used either as a master flash or a remote unit.

Canon Speedlite 430EX

The 430EX is less complicated, more compact, and less expensive than the top models. It offers E-TTL flash control, wireless E-TTL operation, flash exposure compensation, and high-speed synchronization. The 430EX flash unit provides high performance with an ISO 100 GN of 141 (feet), or 43 (meters) with the zoom reflector set for 105mm. The tilt/swivel zoom reflector covers focal lengths from 24 to 105mm. The zoom head operates automatically for focal lengths of 24, 28, 35, 50, 70, 80 and 105mm. A built-in wide-angle pull-down reflector makes flash coverage wide

enough for a 17mm lens. An LCD panel on the rear of the unit makes adjusting settings easy, and there are 6 Custom Functions that are accessible. Since the 430EX supports wireless E-TTL, it can be used as a remote, or slave, unit.

Other Speedlites

The Speedlite 220EX is an economy alternative EX-series flash. It offers E-TTL flash and high-speed sync, but does not offer wireless TTL flash or exposure bracketing.

Close-Up Flash

There are also two specialized flash units for close-up photography that work well with the EOS Rebel XTi. Both provide direct light on the subject.

Macro Twin Lite MT-24EX: The MT-24EX uses two small flashes affixed to a ring that attaches to the lens. These can be adjusted to different positions to alter the light and can be used at different strengths so one can be used as a main light and the other as a fill light. If both flash tubes are switched on, they produce an ISO 100 GN of 72 (feet), or 22 (meters), and when used individually the guide number is 36. It does an exceptional job with directional lighting in macro shooting.

Macro Ring Lite MR-14EX: Like the MT-24EX, the MR-14EX uses two small flashes affixed on a ring. It has an ISO 100 GN of 46 (feet), or 14 (meters) and both flash tubes can be independently adjusted in 13 steps from 1:8 to 8:1. It is a flash that encircles the lens and provides illumination on axis with it. This results in nearly shadow-less photos as the shadow falls behind the subject compared to the lens position, though there will be shadow effects along curved edges. It is often used to show fine detail and color in a subject, but it cannot be used for varied light and shadow effects. This flash is commonly used in medical and dental photography so that important details are not obscured by shadows.

Note: The power pack for both of these specialized flash units fits into the flash shoe of the camera. In addition, both macro flash units offer some of the same technical features as the 580EX, including E-TTL operation, wireless E-TTL flash, and high-speed synchronization. The MT-24EX model can also be used for wireless E-TTL flash.

Note: When the Rebel XTi is used with older system flash units (such as the EZ series), the flash unit must be set to manual, and TTL will not function. For this reason, Canon EX Speedlite system flash units are recommended for use with the camera.

This macro shot was lit by an off-camera Speedlite placed to the right of the subject. A ring light would yield flatter illumination with no shadows or specular highlights, which in this case would not be as desirable. Photo ©Bob Shell

Bounce Flash

Direct flash can often be harsh and unflattering, causing heavy shadows behind the subject or underneath features such as eyebrows and bangs. Bouncing the flash softens the light and creates a more natural-looking light effect. The Canon Speedlite 580EX and 430EX accessory flash units feature heads that are designed to tilt so that a shoe-mounted flash can be aimed at the ceiling to produce soft, even lighting. The 580EX also swivels 180 degrees in both directions, so the light can be bounced off something to the side of the camera, like a wall or reflector. However, the ceiling or wall must be white or neutral gray, or it may cause an undesirable color cast in the finished photo.

Wireless E-TTL Flash

With the Wireless E-TTL feature, you can use up to three groups of Speedlite 580EXs, 430EXs, or the now discontinued 550EXs and 420EXs for more natural lighting or emphasis. (The number of flash groups is limited to three, but the number of actual flash units is unlimited.) The master unit and the camera control the exposure. A switch on the back of the foot of the 580EX (and 550EX) allows you to select whether the flash will be used as a master or a slave flash in the setup. The 420EX can only be used as a remote or slave unit. Other wireless flash options include the Speedlite infrared transmitter (ST-E2), or the Macro Twin Lite MT-24EX.

To operate wireless E-TTL, a Speedlite 580EX (or discontinued 550EX) is mounted in the flash shoe on the camera and the switch on the unit's foot should be set so that it functions as a master unit. Next, the slave units are set up in the surrounding area. The light ratio of slave units can be varied manually or automatically. With E-TTL (wireless) control, several different Speedlite 420EXs, 430EXs, 550EXs, and 580EXs can be controlled at once.

Flash photography needn't be obvious. Flash can freeze moving subjects, fill in harsh shadows, and be a limitless creativity tool.

143

Lenses and Accessories

The Rebel XTi belongs to an extensive family of Canon EOS-compatible equipment, including lenses, flashes, and other accessories. With this wide range of available options, you can expand the capabilities of your camera quite easily should you want to. Canon has long had an excellent reputation for its lenses, and several independent manufacturers offer quality Canon-compatible lenses as well.

The Rebel XTi can use both Canon EF and EF-S lenses, ranging from wide-angle to tele-zoom, as well as single-focal-length lenses, from very wide to extreme telephoto. Keep in mind that both the widest angle and the farthest zoom are multiplied by the Rebel XTi's 1.6x magnification factor. The EF 14mm f/2.8 L lens, for example, is a super-wide lens when used with a 35mm film camera, but offers the 35mm-format equivalent of a 22mm wide-angle lens when attached to the EOS Rebel XTi—wide, but not super-wide. On the other hand, put a 400mm lens on the Rebel XTi and you get the equivalent of a 640mm telephoto—a big boost with no change in aperture. (Be sure to use a tripod for these focal lengths!)

Choosing Lenses

The focal length and design of a lens will have a huge effect on how you photograph. The correct lens will make photography a joy; the wrong one will make you leave the camera at home. One approach for choosing a lens is to determine if you are frustrated with your current lenses. Do you constantly want to see more of the scene than the lens will

Interchangeable lenses for your Rebel XTi offer versatility for your photography. Macro lenses let you get in close and capture detail in smaller subjects, like this shot of water dripping from a flower.

The lens release button, located on the front of the camera beside the lens mount, allows you to easily change lenses.

allow? Then consider a wider-angle lens. Is the subject too small in your photos? Then look into acquiring a zoom or telephoto lens.

Certain subjects lend themselves to specific focal lengths. Wildlife and sports action are best photographed using focal lengths of 300mm or more, although nearby action can be managed with 200mm. Portraits look great when shot with focal lengths between 80 and 100mm. Interiors often demand wide-angle lenses such as 20 or 24mm. Many people also like wide-angles for landscapes, but telephotos can come in handy for distant scenes. Close-ups can be shot with nearly any focal length, though skittish subjects such as butterflies might need a rather long lens.

These focal lengths are traditional 35mm equivalents, because most people who know photography are familiar with these measurements. However, the standard 35mm focal lengths do not act on most digital cameras the way they did with film. That is because digital sensors are smaller than a frame of 35mm film, so they crop the area seen by the lens, essentially creating a different format. Effectively, this magnifies the subject within the image area of the Rebel XTi and results in the lens acting as if it has been multiplied by a factor of 1.6 compared to 35mm film cameras.

Note: This is exactly the same thing that happens when one focal length is used with different sized film formats. For example, a 50mm lens is considered a mid-range focal length for 35mm, but it would be a wide-angle for medium format cameras.

This is great news for the photographer who needs long focal lengths for wildlife or sports. A standard 300mm lens for 35mm film now acts like a 480mm lens on the Rebel XTi. You get a long focal length in a smaller lens, often with a wider maximum f/stop, and with a much lower price tag. But this news is tough for people who need wide-angles, since the width of what the digital camera sees is significantly cropped in comparison to what a 35mm camera would see using the same lens. You will need lenses with shorter focal lengths to see the same amount of wide-angle you may have been used to with film.

Zoom vs. Prime Lenses

When zoom lenses first came on the market, they were not even close to a single-focal-length lens in sharpness, color rendition, or contrast. Today, you can get superb image quality from either type. There are some important differences, though. The biggest is maximum f/stop.

Zoom lenses are rarely as fast (e.g. rarely have as big a maximum aperture) as single-focal-length (prime) lenses. A 28-200mm zoom lens, for example, might have a maximum aperture at 200mm of f/5.6, yet a single-focal-length lens might be f/4 or even f/2.8. When zoom lenses come close to a single-focal-length lens in f/stops, they are usually considerably bigger and more expensive than the single-focal-length lens. Of course, they also offer a whole range of focal lengths, which a single-focal-length lens cannot do. There is no question that zoom lenses are versatile.

EF-Series Lenses

Canon EF lenses include some unique technologies. Canon pioneered the use of tiny autofocus motors in its lenses. In order to focus swiftly, the focusing elements within the lens need to move with quick precision. Canon developed the lens-based ultrasonic motor for this purpose. This technology makes the lens motor spin with ultrasonic oscillation energy instead of the conventional drive-train system (which tends to be noisy). This allows lenses to autofocus nearly instantly with no noise and it uses less battery power than traditional systems. Canon lenses that utilize this motor are labeled USM. (Lower-priced Canon lenses have small motors in the lenses too, but they don't use USM technology, and can be slower and noisier.)

Canon was also a pioneer in the use of image-stabilizing technologies. IS (Image Stabilizer) lenses utilize sophisticated motors and sensors to adapt to slight movement during exposure. It's pretty amazing—the lens actually has vibration-detecting gyrostabilizers that move a special image-stabilizing lens group in response to lens movement. This dampens movement that occurs from handholding a camera and allows much slower shutter speeds to be used. IS also allows big telephoto lenses (such as the EF 500mm IS lens) to be used on tripods that are lighter than would normally be used with non-IS telephoto lenses.

The IS technology is part of many zoom lenses, and does a great job overall. However, IS lenses in the mid-focal length ranges have tended to be slower zooms matched against single-focal-length lenses. For example, compare the EF 28-135mm f/3.5-5.6 IS lens to the EF 85mm f/1.8. The former has a great zoom range, but allows less light at maximum aperture. At 85mm (a good focal length for people), the EF 28-135mm is an f/4 lens, more than two stops slower than the f/1.8 single-focal-length lens, when both are shot "wide-open" (typical of low light situations). While you could make up the two stops in "handholdability" due to the IS technology, that also means you must shoot two full

Telephoto lenses allow you to capture subjects from afar that might not be accustomed to people, such as animals in the wild.

shutter speeds slower, which can be a real problem in stopping subject movement.

EF-S Series Lenses

EF lenses are the standard lenses for all Canon EOS cameras. EF-S lenses are small, compact lenses designed for use on digital SLRs with smaller-type sensors (such as the EOS 20D, 30D, Digital Rebel XT, and the Digital Rebel XTi). They were introduced with the EF-S 18-55mm lens packaged with the original EOS Digital Rebel. They cannot be used with film EOS cameras or with any of the EOS-1D cameras (1D, 1Ds, 1D Mark II, 1Ds Mark II) because the image area for each of those cameras' sensors is larger than that of the Rebel XTi's sensor.

Currently Canon has five EF-S lenses. The EF-S 17-85mm f/4-5.6 IS USM is an image stabilized zoom that offers the 35mm equivalent of approximately 28-135mm in a very compact package. The EF-S 17-55 f/2.8 IS USM offers an image stabilized zoom with a wide aperture and a 35mm equivalent of about a 28-85mm. A more affordable EF-S 18-55mm f/3.5-5.6 USM is available, but without image stabilization.

The EF-S 10-22mm f/3.5-4.5 USM zoom brings an excellent wide-angle range to the Rebel XTi by offering the equivalent of 16-35mm on a full-size 35mm frame. For macro shooting Canon offers the EF-S 60mm f/2.8 Macro USM. The angle of view is similar to a 96mm lens on a 35mm camera and will focus down to life-size magnification.

L-Series Lenses

Canon's L-series lenses use special optical technologies for high-quality lens correction, including low-dispersion glass, fluorite elements, and aspherical designs. UD (ultra-low dispersion) glass is used in telephoto lenses to minimize chromatic aberration, which occurs when the lens cannot focus all colors equally at the same point on the sensor (or on the film in a traditional camera), resulting in less sharpness and contrast. Low-dispersion glass focuses colors more equally for sharper, crisper images.

Fluorite elements are even more effective (though more expensive) and have the corrective power of two UD lens elements. Aspherical designs are used with wide-angle and mid-focal length lenses to correct the challenges of spherical aberration in such focal lengths. Spherical aberration is a problem caused by lens elements with extreme curvature (usually found in wide-angle and wide-angle zoom lenses). Glass tends to focus light differently through different parts of such a lens, causing a slight, overall softening of the image even though the lens is focused sharply. Aspherical lenses use a special design that compensates for this optical defect.

DO-Series Lenses

Another Canon optical design is the DO (diffractive optic). This technology significantly reduces the size and weight of a lens, and is therefore useful for big telephotos and zooms. Yet, the lens quality is unchanged. The lenses produced by Canon in this series are a 400mm pro lens that is only two-thirds the size and weight of the equivalent standard lens, and a 70-300mm IS lens that offers a great focal length range while including image stabilization.

Macro and Tilt-Shift Lenses

Canon also makes some specialized lenses. Macro lenses are single-focal-length lenses optimized for high sharpness throughout their focus range, from very close (1:1 or 1:2) magnifications to infinity. These lenses range from 50mm to 180mm.

Tilt-shift lenses are unique lenses that shift up and down or tilt toward or away from the subject. They mimic the controls of a view camera. Shift lets the photographer keep the back of the camera parallel to the scene and move the lens to get a tall subject into the composition. This keeps vertical lines vertical and is extremely valuable for architectural photographers. Tilt changes the plane of focus so that sharpness can be changed without changing the f/stop. Focus can be extended from near to far by tilting the lens toward the subject, or sharpness can be limited by tilting the lens away from the subject (which has been a trendy advertising photography technique lately).

Independent Lens Brands

Independent lens manufacturers also make some excellent lenses that fit the Rebel XTi. I've seen quite a range in capabilities from these lenses. Some include low-dispersion glass and are stunningly sharp. Others may not match the best

Canon lenses, but offer features (such as focal length range or a great price) that make them worth considering. To a degree, you get what you pay for. A low-priced Canon lens probably won't be much different than a low-priced independent lens. On the other hand, the high level of engineering and construction found on a Canon L-series lens can be difficult to match.

Filters and Close-Up Lenses

Many people assume that filters aren't needed for digital photography because adjustments for color and light can be made in the computer. By no means are filters obsolete! They actually save a substantial amount of work in the digital darkroom by allowing you to capture the desired color and tonalities for your image right from the start. Even if you can do certain things in the computer, why take the time if you can do them more efficiently while shooting?

Of course, the LCD monitor comes in handy once again. By using it, you can assist yourself in getting the best from your filters. If you aren't sure how a filter works, simply try it and see the results immediately on the monitor. This is like using a Polaroid, only better, because you need no extra gear. Just take the shot, review it, and make adjustments to the exposure or white balance to help the filter do its job. If a picture doesn't come out the way you would like, discard it and take another right away.

Attaching filters to the camera depends entirely on your lenses. Usually, a properly sized filter can either be screwed directly onto a lens or fitted into a holder that screws onto the front of the lens. There are adapters to make a given size filter fit several lenses, but the filter must cover the lens from edge to edge or it will cause dark corners in the photo (vignetting). A photographer may even hold a filter over the lens with his or her hand.

There are a number of different types of filters that perform different tasks:

Polarizers

This important outdoor filter should be in every camera bag. Its effects cannot be duplicated exactly with software because it actually affects the way light is perceived by the sensor.

A polarizer darkens skies at 90° to the sun (this is a variable effect), reduces glare (which will often make colors look better), removes reflections, and increases saturation. While you can darken skies on the computer, the polarizer reduces the amount of work you have to perform in the digital darkroom. The filter can rotate in its mount, and as it rotates, the strength of the effect changes. While linear polarizers often have the strongest effect, they can cause problems with exposure, and often prevent the camera from autofocusing. Consequently, you are safer using a circular polarizer with the Rebel XTi.

Neutral Density Gray Filters

Called ND filters, this type is a helpful accessory. ND filters simply reduce the light coming through the lens. These filters come in different strengths, each reducing different quantities of light. They give additional exposure options under bright conditions, such as a beach or snow (where a filter with a strength of 4x is often appropriate). If you like the effects when slow shutter speeds are used with moving subjects, a strong neutral density filter (such as 8x) usually works well. Of course, the great advantage of the digital camera, again, is that you can see the effects of slow shutter speeds immediately on the LCD monitor so you can modify your exposure for the best possible effect.

Graduated Neutral Density Filters

Many photographers consider this filter an essential tool. It is half clear and half dark (gray). It is used to reduce bright areas (such as sky) in tone, while not affecting darker areas (such as the ground). The computer can mimic its effects, but you may not be able to recreate the scene you wanted. A digital

camera's sensor can only respond to a certain range of brightness at any given exposure. If a part of the scene is too bright compared to the overall exposure, detail will be washed out and no amount of work in the computer will bring it back. While you could try capturing two shots of the same scene at different exposure settings and then combining them on the computer, a graduated ND might be quicker.

UV and Skylight Filters
Though many amateur photographers buy these, pros rarely use them. The idea behind them is to give protection to the front of the lens, but they do very little visually. Still, they can be useful when photographing under such conditions as strong wind, rain, blowing sand, or going through brush.

If you use a filter for lens protection, a high quality filter is best, as a cheap filter can degrade the image quality of the lens. Remember that the manufacturer made the lens/sensor combination with very strict tolerances. A protective filter needs to be literally invisible, and only high-quality filters can guarantee that.

Close-Up Lenses
Close-up photography is a striking and unique way to capture a scene. Most of the photographs we see on a day-to-day basis are not close-ups, making those that do make their way to our eyes all the more noticeable. It is surprising to me that many photographers think the only way to shoot close-ups is with a macro lens. The following are four of the most common close-up options:

Close-focusing zoom lenses with a macro or close-focus feature: Most zoom lenses allow you to focus up-close without accessories, although focal-length choices may become limited when using the close-focus feature. These lenses are an easy and effective way to start shooting close-ups. Keep in mind, however, that even though these may say they have a macro setting, it is really just a close-focus setting and not a true macro as described below in option four.

Wide-angle lenses show more of the scene than normal length lenses. They can capture a dramatic foreground subject and include important background information in one shot.

Close-up accessory lenses: You can buy lenses that screw onto the front of your lens to allow it to focus even closer. The advantage is that you now have the whole range of zoom focal lengths available and there are no exposure corrections. Close-up filters can do this, but the image quality is not great. More expensive achromatic accessory lenses (highly-corrected, multi-element lenses) do a superb job with close-up work, but their quality is limited by the original lens.

Extension tubes: Extension tubes fit in between the lens and the camera body of an SLR. This allows the lens to focus much closer than it could normally. Extension tubes are designed to work with all lenses for your camera (although older extension tubes won't always match some of the new lenses made specifically for digital cameras). Be aware that extension tubes cause a loss of light.

Macro lenses: Though relatively expensive, macro lenses are designed for superb sharpness at all distances and will focus from mere inches to infinity. In addition, they are typically very sharp at all f/stops.

Sharpness is a big issue with close-ups, and this is not simply a matter of buying a well-designed macro lens. The other close-up options can also give superbly sharp images. Sharpness problems usually result from three factors: limited depth of field, incorrect focus placement, and camera movement.

The closer you get to a subject, the shallower depth of field becomes. You can stop your lens down as far as it will go for more depth of field or you can use a lens with a wider angle, but depth of field will still be limited. Because of this, it is critical to be sure focus is placed correctly on the subject. If the back of an insect is sharp but its eyes aren't, the photo will appear to have a focus problem. At these close distances, every detail counts. If only half of the flower petals are in focus, the overall photo will not look sharp. Autofocus up close can be a real problem with critical focus placement because the camera will often focus on the wrong part of the photo.

Of course, you can review your photo on the LCD monitor to be sure the focus is correct before leaving your subject. You can also try manual focus. One technique is to focus the lens at a reasonable distance, then move the camera toward and away from the subject as you watch it go in and out of focus. This can really help, but still, you may find that taking multiple photos is the best way to guarantee proper focus at these close distances. Another good technique is to shoot on the Continuous shooting drive mode and fire multiple photos. You will often find at least one shot with the critical part of your subject in focus. This is a great technique when you are handholding and when you want to capture moving subjects.

When you are focusing close, even slight movement can shift the camera dramatically in relationship to the subject. The way to help correct this is to use a high shutter speed or

put the camera on a tripod. Two advantages to using a digital camera during close-up work are the ability to check the image to see if you are having camera movement problems, and the ability to change ISO settings from picture to picture (enabling a faster shutter speed if you deem it necessary).

Close-Up Contrast
The best looking close-up images will often be ones that allow the subject to contrast with its background, making it stand out and adding some drama to the photo. Although maximizing contrast is important in any photograph where you want to emphasize the subject, it is particularly critical for close-up subjects where a slight movement of the camera can totally change the background.

There are three important contrast options to keep in mind:

Tonal or brightness contrasts: Look for a background that is darker or lighter than your close-up subject. This may mean a small adjustment in camera position. Backlight is excellent for this since it offers bright edges on your subject with lots of dark shadows behind it.

Color contrasts: Color contrast is a great way to make your subject stand out from the background. Flowers are popular close-up subjects and, with their bright colors, they are perfect candidates for this type of contrast. Just look for a background that is either a completely different color (such as green grass behind red flowers) or a different saturation of color (such as a bright green bug against dark green grass).

Sharpness contrast: One of the best close-up techniques is to work with the inherent limit in depth of field and deliberately set a sharp subject against an out-of-focus background or foreground. Look at the distance between your subject and its surroundings. How close are other objects to your subject? Move to a different angle so that distractions are not conflicting with the edges of your subject. Try different f/stops to change the look of an out-of-focus background or foreground.

As you get closer to your subject, your depth of field becomes limited, and sharpness in your image can suffer. Use a small aperture and a tripod for extreme close-ups.

Tripods and Camera Support

A successful approach to getting the most from a digital camera is to be aware that camera movement can affect sharpness and tonal brilliance in an image. Even slight movement during the exposure can cause the loss of fine details and the blurring of highlights. These effects are especially glaring when you compare an affected image to a photo that has no motion problems. In addition, affected images will not enlarge well.

You must minimize camera movement in order to maximize the capabilities of your lens and sensor. A steady hold on the camera is a start. Fast shutter speeds, as well as the use of flash, help to ensure sharp photos, although you can

get away with slower shutter speeds when using wider-angle lenses. When shutter speeds go down, however, it is advisable to use a camera-stabilizing device. Tripods, beanbags, monopods, mini-tripods, shoulder stocks, clamps, and more, all help. Many photographers carry a small beanbag or a clamp pod with their camera equipment for those situations where the camera needs support but a tripod isn't available.

Check your local camera store for the variety of stabilizing equipment. A good tripod is an excellent investment. When buying one, extend it all the way to see how easy it is to open, then lean on it to see how stiff it is. Both aluminum and carbon fiber tripods offer great rigidity. Carbon fiber is much lighter, but also more expensive. A new option that is in the middle in price/performance between aluminum and carbon fiber is Basalt. Basalt tripods are stronger than aluminum but not quite as light as carbon fiber.

The head is a very important part of the tripod and may be sold separately. There are two basic types for still photography: the ball head and the pan-and-tilt head. Both designs are capable of solid support and both have their passionate advocates. The biggest difference between them is how you loosen the controls and adjust the camera. Try both and see which seems to work better for you. Be sure to do this with a camera on the tripod because that added weight changes how the head works.

Working with Your Images

Camera to Computer

There are two primary ways of duplicating digital files from the memory card into the computer. One way is to insert the card into an accessory known as a media card reader. Card readers connect to your computer through the USB or FireWire ports and can remain plugged in and ready to download your pictures. The second way is to download images directly from the Rebel XTi using a USB interface cable (included with the camera at the time of purchase).

FireWire (also called iLink or 1394) is faster than some USB but might not be standard on your computer. There are several types of USB: USB 1.0, USB 2.0, and USB 2.0 Hi-Speed. Older computers and card readers will have the 1.0 version, but new devices are most likely 2.0 Hi-Speed. This new version of USB is much faster than the old. However, if you have both versions of USB devices plugged into the same bus, the older devices will slow down the speed of the faster devices.

The advantage of downloading directly from the camera is that you don't need to buy a card reader. However, there are some distinct disadvantages. For one, cameras generally download much more slowly than card readers (given the same connections). Plus, a camera has to be unplugged from the computer after each use, while the card reader can be left attached. In addition to these drawbacks, downloading directly from a camera uses its battery power in making the transfer (or you need to plug it into AC power).

⟵ *The Rebel XTi makes it easy to transfer your images from the camera to the computer. It also includes a direct printing feature, compatible with certain Canon printers.*

The Card Reader

A card reader can be purchased at most electronics stores. There are several different types, including single-card readers that read only one particular type of memory card, or multi-readers that are able to utilize several different kinds of cards. (The latter are important with the Rebel XTi only if you have several cameras using different memory card types.)

After your card reader is connected to your computer, remove the memory card from your camera and put it into the appropriate slot in your card reader.

The card will usually show up as an additional drive on your computer (on Windows XP and Mac OS 9 and OS X operating systems; for other versions you may have to install the drivers that come with the card reader). When the computer recognizes the card, it may also give instructions for downloading. You may want to follow these instructions if you are unsure about opening and moving the files yourself, but this is much slower than simply selecting your files and dragging them to where you want them. Make sure you "eject" the card before removing it from the reader. On Windows you can right click on the drive and select eject; on a Mac, you can just drag the drive to the trash.

Card readers can also be used with laptops, though PC card adapters may be more convenient when you're on the move. As long as your laptop has a PC card slot, all you need is a PC card adapter for your particular type of memory card. Insert the memory card into the PC adapter, and then insert the PC adapter into your laptop's PC card slot. Once the computer recognizes this as a new drive, and you can drag and drop images from the card to the hard drive. The latest PC card adapter models tend to be faster but are also more expensive.

The Rebel XTi allows you to choose which images you print and in what order with the Direct Print Order Format (DPOF) feature.

Working with Files

How do you edit and file your digital photos so that they are accessible and easy to use? To start, it helps to create folders specific to groups of images (i.e., Outdoors, Sports, State Fair, Furniture Displays, etc.). You can organize the photo folders alphabetically or by date inside a "parent" folder.

Be sure to edit your photos and remove extraneous shots. Unwanted photos stored on your computer waste storage space on your hard drive, so you should store only those you intend to keep. Take a moment and review your pictures while the card is still in the camera. Erase the ones you don't want, and download the rest. You can also delete photos once they are downloaded to the computer by using a browser program (described below).

Here's how I deal with digital camera files. First, I set up a filing system. I use a memory card reader that shows up as a drive on my computer. Using the computer's file system, I open the memory card as a window or open folder (this is the same basic view on both Windows and Mac computers) showing the images in the appropriate folder. I then open another window or folder on the computer's hard drive, and create a new subfolder labeled to signify the photographs on the memory card, such as Place, Topic, Date. I also create all of these folders in a specific location on my hard drive—I use a folder called Digital Images. Inside that, I have folders by year, then the individual shoots (you could use locations, months, whatever works for you). This is really no different than setting up an office filing cabinet with hanging folders or envelopes to hold photos. Consider the Digital Images folder to be the file cabinet, and the individual folders inside to be the equivalent of the file cabinet's hanging folders.

Next, I select all the images in the memory card folder and drag them to this new folder. This copies all the images onto the hard drive and into my "filing cabinet". It is actually better than using a physical filing cabinet because, for example, I can use browser software to rename all the photos in the new folder, giving information about each photo, for example using the title _SalzburgOct06.

I also set up a group of folders in a separate "filing cabinet" (a new folder at the level of Digital Images) for edited photos. In this second filing cabinet, I include subfolders specific to types of photography, such as landscapes, close-ups, people, etc. Inside these subfolders, I can break down categories even further when that helps to organize my photos. I place copies of original images that I have examined and decided are definite keepers, both unprocessed (direct from the camera) and processed images (keeping such files separate). Make sure these are copies (rather than simply moving the files here), as it is important to keep all "original" photo files in the original folder that they went to when first downloaded.

Once you have downloaded your images onto the computer, it helps to burn them to a quality CD as soon as possible. CDs take the place of negatives in the digital world. Storing your images only on your hard drive makes you vulnerable. If copies of an important photo project are stored exclusively on your computer, something could happen to them. Set up a CD binder for your digital "negatives". You may want to keep your original and edited images on separate discs (or separate folders on the same disk). DVD is another alternative, and although it is a common medium, at this point it is not 100% that you'd be able to access it on any computer.

Browser Programs

While the latest version of Adobe Photoshop has an improved browser that can help organize photos, it still doesn't do as well as software specifically made for this purpose. There are currently a number of programs that help view and organize your images.

ACDSee is a superb program with a customizable interface, keyboard tagging of images, and some unique characteristics such as a calendar feature that lets you find photos by date (though the best-featured version is Windows only). Another very good program with similar capabilities is iView Media (with equal features on both Windows and Mac versions). Apple's Aperture uses a digital "loupe" for magnifying your images while browsing (it is only available for the Mac). You may also want to check out Canon's Digital Photo Professional, which is included with the software that comes with the Rebel XTi. It is also the only software that is able to utilize Canon's Dust Delete Data detection system (see page 50).

All of these browser programs include some database functions (such as keyword searches) and many will operate on both Windows and Mac platforms. These programs allow you to quickly look at photos on your computer, edit them, rename them one at a time or all at once, read all major

It helps to organize your photos into a filing system, especially since digital technology allows you to shoot images without processing costs. If you don't start a filing system from the beginning, it can turn into a major project down the road.

files, move photos from folder to folder, resize photos for email, create simple slideshows, and more.

An important function of browser programs is their ability to print customized index prints. You can then give a title to each of these index prints, and also list additional information about the photographer, as well as the photo's file location. The index print is a hard copy that allows easy reference (and visual searches). You could include an index print with every CD you burn so you can quickly see what is on the CD and find the file you need. A combination of uniquely labeled file folders on your hard drive, a browser program, and index prints will help you to maintain a fast and easy way of finding and sorting images.

Image Processing

Of course, you can process the Rebel XTi's JPEG files in any image-processing program. One nice thing about JPEG is that it is one of the most universally recognized formats. Any program on any computer that recognizes image files will recognize JPEG. That being said, it is important to understand that the original JPEG file is more like a negative than a slide. Sure, you can use it directly, just like you could have the local mini-lab make prints from negatives. But JPEG files can be processed to get more out of them.

While RAW files offer more capacity for change, you can still do a lot with a JPEG file to optimize it for use. I shoot a lot of JPEG when it fits my workflow, and no one complains about the quality of my images.

RAW, as mentioned earlier, is an important format because it increases the options for adjustment of your images. In addition, Canon's RAW file, CR2, offers increased flexibility and control over the image. When shooting RAW, you have to work on every image, which changes your workflow. This is why photographers who sometimes, but not always, need to work with RAW will use the Rebel XTi's ability to record RAW and JPEG at the same time.

A big advantage to the RAW file is that it captures, more directly, what the sensor sees. It holds more information (12-bits vs. the standard 8-bits per color) and can have stronger correction applied to it (compared to JPEG images) without problems appearing. This can be particularly helpful when there are difficulties with exposure or color balance. (Remember that the image file from the camera holds 12-bits of data even though it is contained in a 16-bit file—so while you can get a 16-bit TIFF file from the RAW file, it is based on 12 bits of data.)

Note: Rebel XTi RAW files are about 10 MB in size, so they will fill memory cards quite quickly. In addition, they can increase processing and workflow times.

Canon offers two ways of converting CR2 files to standard files that can be optimized in an image editor like Photoshop: a file viewer utility (Zoom Browser for Windows or Image Browser for Mac) and the Digital Photo Professional software. In addition, Photoshop CS2 has a built-in RAW converter, and Capture One software (from Phase One) has some high-level features for RAW conversion and workflow that many photographers like. There is a slight quality difference between using the latter two programs and using the Canon software, which after all was created specifically for Canon's proprietary RAW file. However, the difference is small.

The File Viewer Utility

Canon's Zoom Browser (Windows)/Image Browser (Mac), supplied with the camera, is easy to use. It is a good program that lets you view and organize RAW and JPEG files. It will convert RAW files, though it is a pretty basic program and doesn't offer some of the features available in other RAW processing software. Even so, it does a very good job of translating details from the RAW file into TIFF or JPEG form. Once converted, the new TIFF or JPEG files are readable by any image-processing program. TIFF is the preferred file format (JPEG would only be used if you had file space limitations). The browser supplied with the Rebel XTi is much faster than earlier versions. In addition, it includes EOS Capture, a remote capturing control that lets you work your camera remotely when attached to the computer.

Digital Photo Professional Software

Once an optional program and now included with the Rebel XTi, Digital Photo Professional (DPP) was developed to bring Canon RAW file processing up to speed with the rest of the digital world. (Even Canon admitted the file viewer utility did not have the power of competitive programs, yet it was their only RAW conversion program.) This program has a brand-new processing engine. It can be used to process both CR2 files and JPEG files. The advantage to processing JPEG files is that DPP is

quicker and easier to use than Photoshop CS2, yet is still quite powerful. For fast and simple JPEG processing, DPP works quite well. I believe if you are going to shoot RAW, this is a must-use program. It is fast, full-featured and gives excellent results.

One big advantage that Digital Photo Professional offers over any other RAW processing program is being able to use Dust Delete Detection Data that is embedded in the RAW file (see page 50).

Storing Your Images

Your digital images can be lost or destroyed without proper care. Many photographers back up their image files with a second drive, either added to the inside of the computer or as an external USB or FireWire drive. For more permanent backup, it is recommended to burn your images to CD.

Hard drives and memory cards do a great job at recording image files for processing, transmitting, and sharing, but are not good for long-term storage. This type of media has been known to lose data within ten years. And since drives and cards are getting progressively larger, the chance that a failure will wipe out thousands of images rather than "just one roll" is always increasing.

Computer viruses can also wipe out image files from a hard drive. And even the best drives can crash, rendering them unusable. Plus, we are all capable of accidentally erasing or saving over an important photo.

The answer to these storage problems is optical media. A CD-writer (or "burner") is a necessity for the digital photographer. DVD-writers work extremely well, too, and DVDs can handle about seven times the data that can be saved on a CD. Either option allows you to back up photo files and store images safely.

There are two types of disk media that can be used for recording data: R designated (i.e. CD-R or DVD-R) recordable disks; and RW designated (i.e. CD-RW or DVD-RW) rewritable disks. CD-R disks can only be recorded once—they cannot be erased and no new images can be added to them. CD-RWs, on the other hand, can be recorded on, erased, reused later, and you can add more data to them as well. However, if you want long-term storage of your images, use CD-R disks rather than CD-RWs. (The latter is best used for temporary storage, such as transporting images to a new location.) The storage medium used for CD-R disks is more stable than that of CD-RWs (which makes sense since the CD-RWs are designed to be erasable).

Buy quality media. Inexpensive disks may not preserve your photo-image files as long as you would like them to. Read the box. Look for information about the life of the disk. Most long-lived disks are labeled as such and cost a little more. And once you have written to the disc, store and handle it properly.

Direct Printing

With certain compatible Canon printers, you can control the printing directly from the Rebel XTi. Simply connect the camera to the printer using the dedicated USB cord that comes with the printer. With Canon printers supporting these features, you have access to many direct printing options including:
• Contact sheet style 35-image index prints
• Print shooting information
• Face brightening
• Red-eye reduction
• Print sizes: 4x8, 10x12, 8x10, 14x17
• Support for other paper types
• Print effects: Natural, B/W, Cool Tone, Warm Tone

In addition, the camera is PictBridge compatible, meaning that it can be directly connected to PictBridge printers from several manufacturers. Nearly all new photo printers are PictBridge compatible. With these printers, you use the USB cord that comes with the camera.

Note: RAW files cannot be used for the direct printing options mentioned in this section.

To start the process, first make sure that both the camera and the printer are turned off and connect the camera to the printer with the camera's USB cord. (The connections are straightforward since the plugs only work one way.) Turn on the printer first, then the camera—this lets the camera recognize the printer so it is prepared to control it. (Some printers may turn on automatically when the power cable is connected.) Depending on the printer, the actual direct printing features of the camera will vary.

Press the Playback button ▶ and use the Cross Keys ✧ to select an image on the LCD monitor that you want to print. This icon ✔ will display in the upper left to indicate the printer is connected. Press the SET button ⒮ⓔⓣ and the <Print Setting> screen will appear, giving such printing choices as whether to imprint the date, to include effects, number of copies, trimming area, and paper settings (size, type, borders or borderless). Trimming is a great choice because it allows you to crop your photo right in the LCD monitor before printing, so you can tighten up the composition if needed. Trimming is accomplished by using the ✱ ⊡⋅Q /⊞ Q buttons to adjust the size of the crop, and then the Cross Keys ✧ to adjust the position of the crop. Press ⒮ⓔⓣ to accept the crop setting.

Continue to use the ✧ and ⒮ⓔⓣ to select other desired settings. These choices may change depending on the printer; refer to the printer's manual if necessary.

Be sure to save your images in several locations. Backing up to a CD is highly recommended, especially with images that you have perfected either with the camera features or in an image processing program on the computer.

Once you have selected the options you want, then select Print to start the printing. The Print/Share button ⎙∿ will flash alerting you not to disconnect the USB cable. If you wish to use the same settings for additional prints, use the ✥ or the Main dial 🖘 to move to the next picture and then simply press ⎙∿ to print the next image.

Note: The amount of control you have over the image when printing directly from the camera is limited solely by the printer. Often you will have little or no control over color and brightness. If you really need image control, print from the computer.

If you are shooting a lot of images for direct printing, do some test shots and set up the Rebel XTi's Picture Styles to optimize the prints before shooting the final pictures. You may even want to create a custom setting that increases sharpness and saturation just for this purpose.

Digital Print Order Format (DPOF)

Another printing feature of the Rebel XTi is DPOF (Digital Print Order Format). This allows you to decide which images to print before you actually do any printing. Then, if you have a printer that recognizes DPOF, it will automatically print the chosen images. It is also a way to select images on a memory card for printing at a photo lab. When you drop off your CF card with images selected using DPOF—assuming the lab's equipment recognizes DPOF (ask before you leave your card)—the lab will know which prints you want.

DPOF is accessible through the Playback menu ▶ under <Print Order>. You can set the options you want, choosing all or any combination of individual images. Select <Set Up> to choose Print Type (Standard, Index, or Both), Date (On or Off), and File No. (On or Off). After setting up your choices, press MENU to return to <Print Order>. From there, select to choose either <Order> or <All>. <Order> allows you to use the ✛ to select the individual images you want to print, along with their quantity, while <All> selects all the images on the card for printing. RAW files cannot be selected for DPOF printing.

Glossary

aberration
An optical flaw in a lens that causes the image to be distorted, or unclear.

Adobe Photoshop Elements
Adobe image-editing software. Enables quick red-eye removal, photo cropping, contrast and color adjustment, panoramic assist, and more.

AE
See automatic exposure.

AF
See automatic focus.

angle of view
The area seen by a lens, usually measured in degrees across the diagonal of the film frame.

aperture
The opening in the lens that allows light to enter the camera. Apertures are usually described as f/numbers. The higher the f/number, the smaller the aperture. The lower the f/number, the larger the aperture.

aperture priority
A type of automatic exposure in which you manually select the aperture and the camera automatically selects the shutter speed.

artifact
Misinterpreted information from a compressed digital image. Appears as color flaws or lines through the image.

artificial light
Usually refers to any light source that doesn't exist in nature, such as incandescent, fluorescent, and other manufactured lighting.

astigmatism
A defect that occurs when a lens is unable to focus oblique light rays on a point.

automatic exposure
When the camera calculates and adjusts the amount of light necessary to properly form an image on the sensor.

automatic flash
An electronic flash unit that reads the light reflected from a subject, fires, then shuts itself off as soon as ample light has reached the sensor.

automatic focus
When the camera automatically adjusts the focusing ring on the lens to sharply render the subject.

ambient light
See available light.

Av
Aperture Value. An abbreviated way to indicate f/stops (aperture settings). This term is also used to indicate Aperture-Priority (Av) mode.

available light
The amount of illumination at a given location. Applies to natural and environmental light sources but not those supplied specifically for photography. Also called existing light or ambient light.

backlight
Light that projects toward the camera from behind the subject.

backup
A copy of a file or program made to ensure that, in the case of the original being lost or damaged, the necessary information is still intact.

barrel distortion
A defect in the lens that makes straight lines curve outward away from the middle of the image.

bellows
A lightproof, flexible "tunnel" (usually looks like an accordion) located between the lens and the viewing screen. Moves the optical center of the lens further from the film plane, allowing the lens to focus closer.

bit
Stands for binary digit. The basic unit of binary computation. See also, byte.

bit depth
The number of bits per pixel. Determines the number of colors the image can display. Eight bits per pixel are necessary for a quality photographic image.

bounce light
Light that reflects off another surface, before illuminating the subject.

brightness

A subjective measure of illumination. See luminance.

buffer

Temporarily stores data so that other programs, on the camera or the computer, can continue to run while data is in transition.

built-in meter

A light measuring device that is incorporated into the camera body

bulb

The shutter speed setting that comes after 30". Allows the shutter to stay open as long as the shutter release is depressed.

byte

Eight bits. See also, bit.

card reader

Device that connects to your computer through the USB port. Enables quick and easy download of images from memory card to computer.

chromatic aberration

Occurs when light rays of different colors are focused on different planes, causing colored halos around objects in the image.

chrominance

A form of noise that appears as a random scattering of densely packed colored "grain." See also, luminance and noise.

close-up

A general term used to describe an image created by closely focusing on a subject. Often involves the use of special lenses, bellows, or extension tubes. Also a programmed image control mode that automatically selects a large aperture.

CMOS

Stands for complementary metal oxide semiconductor. Uses both negative and positive polarity circuits. CMOS chips use less power than chips with only one type of transistor.

color balance

The sensor's interpretation of the actual colors of the subject.

color cast

A colored hue over the image often caused by improper lighting or incorrect white balance settings. Can be produced intentionally for creative effect.

color space
A template for determining appropriate hue, brightness, and color saturation.

CompactFlash (CF) card
One of the most widely used removable memory cards.

complementary colors
Any two colors of light that, when combined, emit all known light wavelengths, resulting in white light. Also, any pair of dye colors that absorb all known light wavelengths, resulting in black.

compression
Method of reducing file size through removal of superfluous data, as with the JPEG file format.

contrast
The difference in luminance, density, or darkness, between two tones.

contrast filter
A colored filter that lightens or darkens the monotone representation of a colored area or object in a black-and-white photograph.

corrective filter
Used when shooting black-and-white photographs, a colored filter that allows the film

to record brightness values as they are perceived by the human eye.

critical focus
The most sharply focused point of an image.

cropping
The process of extracting a portion of the image area. If this portion of the image is enlarged, the pixels enlarge with it and resolution is lowered.

daylight
A white balance setting that renders accurate color, when shooting in light conditions like noonday sunlight, with a blue flashbulb, or electronic flash.

dedicated flash
An electronic flash unit that automatically sets the shutter to the proper synchronization speed and usually also activates a signal in the viewfinder that indicates that the flash is fully charged.

default
The setting automatically selected by the camera or computer unless otherwise specified by the user.

depth of field
The image space in front of and behind the plane of focus which appears acceptably sharp in the photograph.

diaphragm
A mechanism that determines the size of the opening that allows light to pass into the camera when taking a photo.

digital zoom
A zoom effect that does not in fact allow closer focus of the subject, but rather enlarges the digital image and, thereby, enlarges the pixels and lowers resolution.

diopter
A measurement of the refractive power of a lens, or a supplementary lens, which is defined by its focal length and power of magnification.

download
The transfer of data from one device to another, such as from camera to computer or computer to printer.

dpi
Stands for dots per inch. Refers to printing resolution.

dye sublimation printer
Creates color on the printed page by vaporizing inks, which then solidify on the page.

EI
See exposure index.

electronic flash
A device with a glass or plastic tube filled with gas that, when electrified, creates an intense flash of light. Also called a strobe. Unlike a flash bulb, it is reusable.

EV
See exposure value.

exposure
When light enters the camera and reacts with the sensor. Can also be the amount of light that strikes the sensor.

exposure index
A rating of the sensor's light sensitivity, usually abbreviated to EI. Similar to an ISO rating.

exposure meter
See light meter.

extension tube
A hollow metal ring that can be fitted between the camera and lens. Increases the distance between the optical center of the lens and the sensor. Decreases the minimum focus distance of the lens.

file format

The form in which digital images are stored and recorded, i.e. GIF, JPEG, RAW, TIFF, etc.

filter

Usually a piece of plastic or glass. Used to control how certain wavelengths of light are recorded. Absorbs selected wavelengths, preventing them from reaching the sensor. Also, software available in image editing programs that can produce filter effects for your image on the computer.

flare

Unwanted light streaks or rings that appear in the viewfinder, on the recorded image, or both. Caused by unwanted light entering the camera during shooting. Use of a lens hood can often prevent this undesirable effect.

f/number

See f/stop.

focal length (f)

When the lens is focused on infinity, it is the distance from the optical center of the lens to the focal plane.

focal plane

The plane on which a lens forms a sharp image. Also, the film plane or sensor plane.

focus

An optimum sharpness or image clarity that occurs when camera settings combine to create a precise convergence of light rays from the lens. Also, the act of adjusting the lens to achieve optimal image sharpness.

frame

The outside perimeter of an image. The edges around an image.

f/stop

The size of the aperture or diaphragm opening of a lens. Also referred to as f/number or stop. Stands for the ratio of the focal length (f) of the lens to the width of its aperture opening. (Ex. f/1.4mm = wide opening and f/22mm = narrow opening.) Each stop up (lower f/number) doubles the amount of light reaching the sensor. Each stop down (higher f/number) halves the amount of light reaching the sensor.

GIF

Stands for graphics interchange format. PC image file format.

gigabyte (GB)
Just over one billion bytes.

gray card
A card used to take accurate exposure readings. Typically has a white side that reflects 90% of the light and a gray side that reflects 18%.

grayscale
A successive series of tones ranging between black and white.

guide number (GN)
A number used to quantify the output of a flash unit. Derived by using this formula: GN = aperture x distance. Guide numbers are expressed in either feet or meters.

hard drive
A contained storage unit made up of magnetically sensitive disks.

histogram
A graphic representation of image tones.

hot shoe
An electronically connected flash mount on the camera body. Enables direct connection between the camera and an external flash. Syncs the shutter release with the firing of the flash.

hyperfocal distance
When focused at infinity, there is an area in front of the infinite focus that also appears sharp. The point closest to you that is still in sharp focus marks the hyperfocal distance. If you then focus the lens on this point, your depth of field increases to include sharp focus of any objects within the range of half the hyperfocal distance and infinity.

icon
An onscreen symbol used to represent a file, function, or program on the camera or computer.

image-editing program
Software that allows for image alteration and enhancement.

infinity
A term used to denote the theoretical most distant point of focus.

interpolation
Process used to maintain resolution when re-sizing an image. Fills in additional space by reading the values of adjacent pixels and mimicking them.

ISO
Traditionally applied to film, this number indicates the relative light sensitivity of the

recording medium—the sensor, in this case. Can be adjusted for each shot on the Digital Rebel.

JPEG
Stands for Joint Photographic Experts Group. A lossy compressive file format developed by the International Standards Organization. Loss in image quality is not necessarily apparent to the eye, but may effect the extent of quality image alteration possibilities due to insufficient data.

kilobyte (KB)
Just over one thousand bytes.

latitude
The acceptable range of exposure (from under to over) determined by observed loss of image quality.

LCD
Stands for liquid crystal display. A flat screen with two clear polarizing sheets on either side of a liquid crystal solution. When activated by an electric current, it causes the crystals to either pass through or block light.

lens
A piece of optical glass on the front of your camera that has been precisely calibrated to

allow you to focus on your subjects.

lens hood
A short tube that can be attached to the front of a lens to prevent flare. Keeps undesirable light from reaching the front of the lens. Also called a lens shade.

lens shade
See lens hood.

light meter
Also called an exposure meter, it is a device that measures light levels and calculates the correct aperture and shutter speed.

long lens
See telephoto lens.

lossless
Image compression in which no data is lost.

lossy
Image compression in which data is lost and, thereby, image quality is lessened. The greater the compression, the lesser the image quality.

luminance

A term used to describe directional brightness. Also, a form of noise that appears as a sprinkling of black "grain." See also, chrominance and noise.

macro lens

Used for close-up photography subjects, such as flowers.

main light

The primary or dominant light source. Influences texture, volume, and shadows.

manual exposure

A camera operating mode that allows you to determine and set both the aperture and shutter speed yourself. The opposite of automatic exposure— the mode in which the camera makes these decisions for you.

megabyte (MB)

Just over one million bytes.

megapixel

A million pixels. Used to describe digital camera resolution capacity, as well as digital image quality.

memory

The storage capacity of a hard drive or recording media.

memory card

Typical recording media of digital cameras. Can be used to store still images, moving images, or sound, as well as related file data. There are several different types, i.e. Compact Flash, Smart Media, XD, Memory Stick, etc. Individual card capacity is limited by available megabyte storage as well as by the quality of the recorded data; image resolution, for example.

menu

An on-screen listing of user options.

middle gray

An average gray tone with18% reflectance. See also, gray card.

midtone

Appears as medium brightness, or medium gray tone, in a print.

mode

Specified operating conditions of the camera or software program.

noise

The digital equivalent of grain. Often caused by sensor or other internal electronic heat. Usually undesirable, but may be added for creative effect using an image-editing pro-

gram. See also, chrominance and luminance.

normal lens
See standard lens.

overexposed
When too much light is recorded with the image.

pan
Moving the camera to follow a moving subject. Creates an image in which the subject appears sharp and the background is blurred.

perspective
The perceived size and depth of objects in an image.

PICT
Short for picture file. File format developed by Apple. Especially useful for compression involving areas of solid color.

pincushion distortion
A flaw in a lens that causes straight light rays to bend inward toward the middle of an image.

pixel
Short for picture element. Base component of a digitized image. Every individual pixel has distinct color and tone.

plug-in
Third-party software created to augment an existing software program.

polarization
Achieved either by using a polarizing filter or software filter effect. Minimizes reflections from non-metallic surfaces like water and glass. Often makes skies appear bluer and less hazy.

RAM
Stands for random access memory. A computer's memory capacity, directly accessible from the central processing unit.

RAW
An image file format that has little or no internal processing applied by the camera. Contains 12-bit color information, more complete data than other file formats offer.

resolution
Refers to image quality and clarity, measured in pixels or megapixels. Also, lines per inch on a monitor, or dots per inch on a printed image.

saturation
Refers to dominant, pure color lacking muddied tones.

sharp
A term used to describe the quality of an image?clear, crisp, and perfectly focused, as opposed to fuzzy, obscure, or unfocused.

short lens
A lens with a short focal length. It produces a greater angle of view than you would see with your eyes.

shutter
The apparatus that controls the amount of time during which light is allowed to reach the sensor.

shutter priority
An exposure mode in which you manually select the shutter speed and the camera automatically selects an aperture to match.

single-lens reflex (SLR)
A camera with a mirror that reflects the image entering the lens through a pentaprism onto the viewfinder screen. When you take the picture, the mirror reflexes out of the way, the focal plane shutter opens, and the image is recorded.

standard lens
A fixed-focal-length lens usually in the range of 45 to

55mm. Gives a realistically proportionate perspective of the scene, in contrast to wide-angle or telephoto lenses. Also known as a normal lens.

stop
See f/stop.

stop down
To reduce the size of the diaphragm opening. Use a higher f/number.

stop up
To increase the size of the diaphragm opening. Use a lower f/number.

strobe
Abbreviation for stroboscopic. An electronic light source that produces a series of evenly spaced bursts of light.

synchronize
Causing a flash unit to fire simultaneously with the complete opening of the camera's shutter.

taking lens
The lens through which the light passes into the camera and onto the sensor.

telephoto effect
When objects in an image appear closer than they really are through the use of a telephoto lens.

telephoto lens
A lens with a long focal length that enlarges the subject and produces a narrower angle of view than you would see with your eyes.

thumbnail
A miniaturized representation of an image file.

TIFF
Stands for tagged image file format. Uses lossless compression.

tripod
A three-legged stand that stabilizes the camera and eliminates camera shake caused by body movement or vibration. Usually adjustable for height and angle.

Tv
Abbreviation for time value. On the camera body, it refers to shutter–priority mode.

USB
Stands for universal serial bus. An interface standard that allows outlying accessories to be plugged and unplugged from the computer while it is turned on. Enables high-speed data transfer.

vignetting
A reduction in light at the edge of an image due to use of a filter or an inappropriate lens hood for the particular lens.

viewfinder screen
The ground glass surface on which you view your image. Features autofocus points.

wide-angle lens
Produces a greater angle of view than you would see with your eyes, often causing the image to appear stretched. See also, short lens.

zoom lens
A lens that can be adjusted to cover a wide range of focal lengths.

Index

Cannon
NB — 2LH

Notes

10.1 megapixel

0.03937 $\frac{mm}{in}$

dia 1.05043" 0.583" 0.874

digital sensor size 14.8mm × 22.2mm

film " " 24mm × 36mm

digital equivalent focal length 1.6

digital	film
18 mm	29 mm
31 mm	50 mm
55 mm	88 mm
150 mm	240 mm
250 mm	400 mm
270 mm	438 mm

300 mm 480

Tamron Lense
 18 to 270mm
 f 3.5 – 6.3
 Ø 62 Di II 8008 62mm
 SN 068102

Canon EOS Rebel xti
 DS 126151 126151
 SN 162120661

Battery Cannon NB-2LH

192